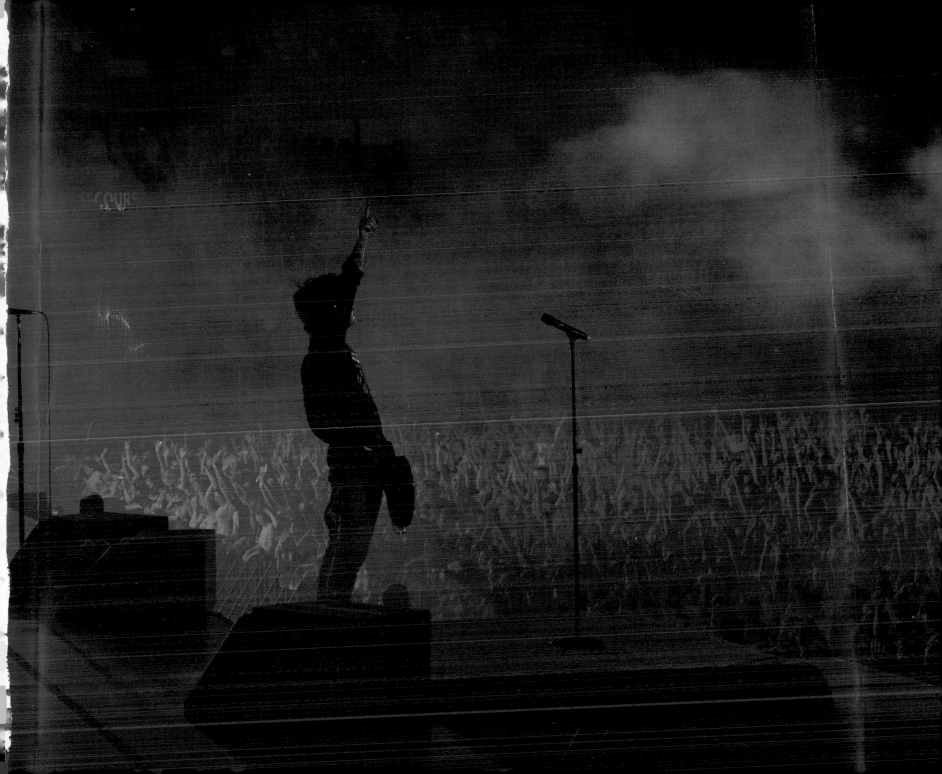

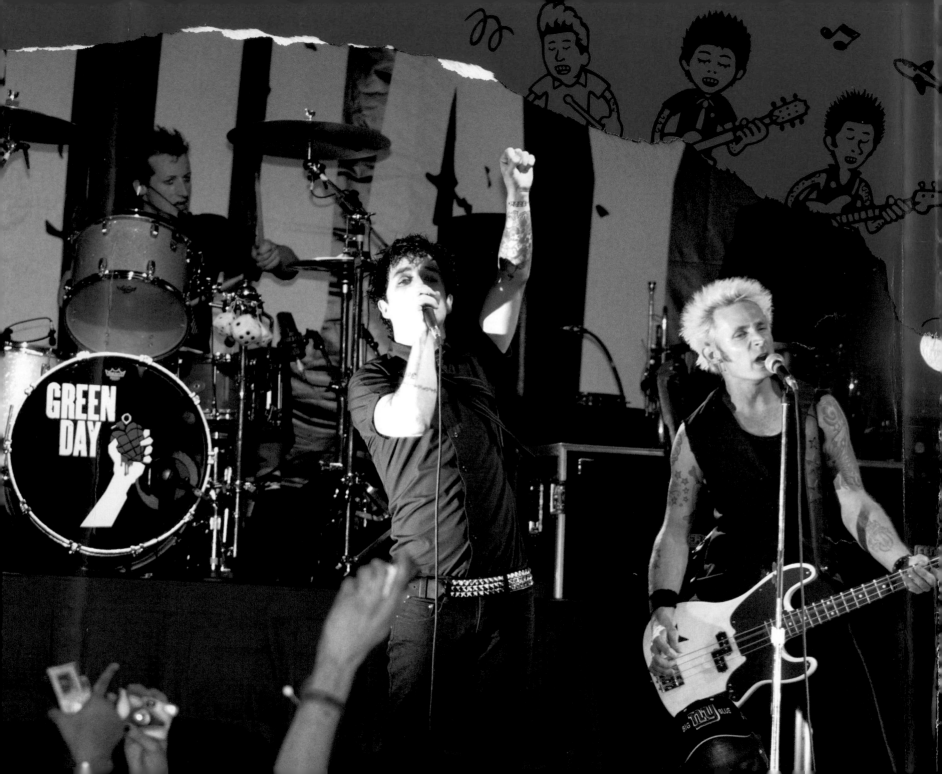

GREEN DAY

PHOTOGRAPHS BY

BOB GRUEN

WITH COMMENTARY BY GREEN DAY

INTRODUCTION BY BILLIE JOE ARMSTRONG

FOREWORD BY JESSE MALIN

ILLUSTRATIONS BY AVI SPIVAK

ABRAMS IMAGE NEW YORK

Design by Shawn Dahl, dahlimama inc

Editors: Charles Kochman and Tamar Brazis

Editorial Assistant: Jessica Gotz

Managing Editor: Connor Leonard

Production Manager: Denise LaCongo

Library of Congress Control Number: 2018958807

ISBN: 978-1-4197-3480-9

eISBN: 978-1-68335-677-6

Printed and bound in China

10 9 8 7 6 5 4 3 2 1

Abrams Image books are available at special discounts when purchased in quantity for premiums
and promotions as well as fundraising or educational use. Special editions can also be created to
specification. For details, contact specialsales@abramsbooks.com or the address below.

Abrams Image® is a registered trademark of Harry N. Abrams, Inc.

ABRAMS The Art of Books
195 Broadway, New York, NY 10007
abramsbooks.com

PAGE 1 Parc des Princes, Paris, France, June 26, 2010
PAGE 2 Park Place, NYC, September 22, 2004
OPPOSITE Madison Square Garden, NYC, May 31, 2002
LAST PAGE Paris, France, June 24, 2010

Rock & roll is the freedom to express your feelings
very loudly, in public!
This book is dedicated to rock & roll.

—B. G.

ACKNOWLEDGMENTS

To the Green Day band—
Billie Joe Armstrong, Mike Dirnt,
Tré Cool, Jason White, Jason Freese,
and Jeff Matika—thank you for your
trust and friendship over the years. This
book couldn't be possible without you!

Special thanks to Jesse Malin for the initial
introductions to both Green Day and this
book. Thank you to Green Day's management
assistant, Bill Schneider; to Jonathan Daniel
and Scott Nagelberg at Crush MGMT for their
help; and to the band's head of security, Eddie
Mendoza, for always looking out for me. Big
thanks to everyone at Abrams—Charles Kochman,
Tamar Brazis, Shawn Dahl, Connor Leonard,
Denise LaCongo, and Jessica Gotz for making this
project happen. Thanks to illustrator Avi Spivak
for adding a bit of Green Day's spirit to this
book in drawing form. And finally, thank you to
my team at Bob Gruen Studio—Richelle DeLora,
Mandi Newall, Hanna Toresson, David Appel, Sarah
Field, and Linda Rowe for all of your help. And
especially thanks to my wife, Elizabeth Gregory,
for seeing me through this project.

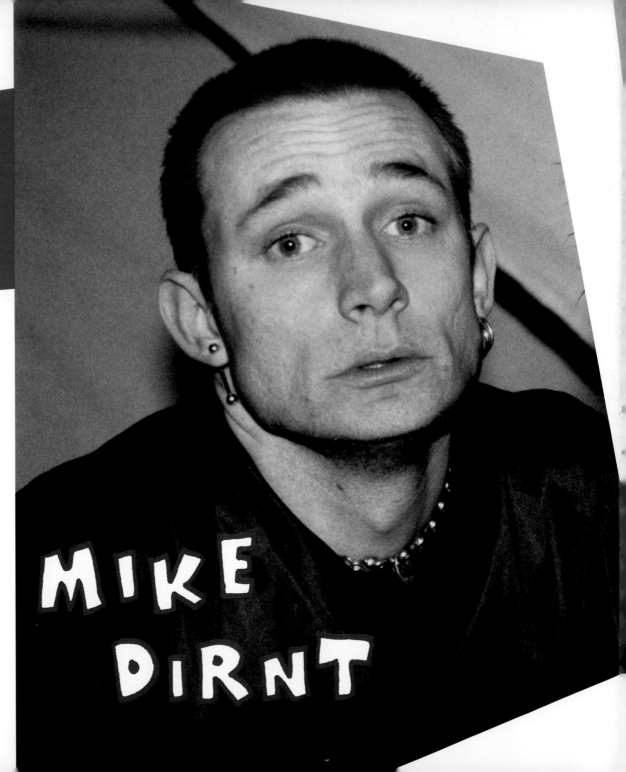

MIKE DIRNT

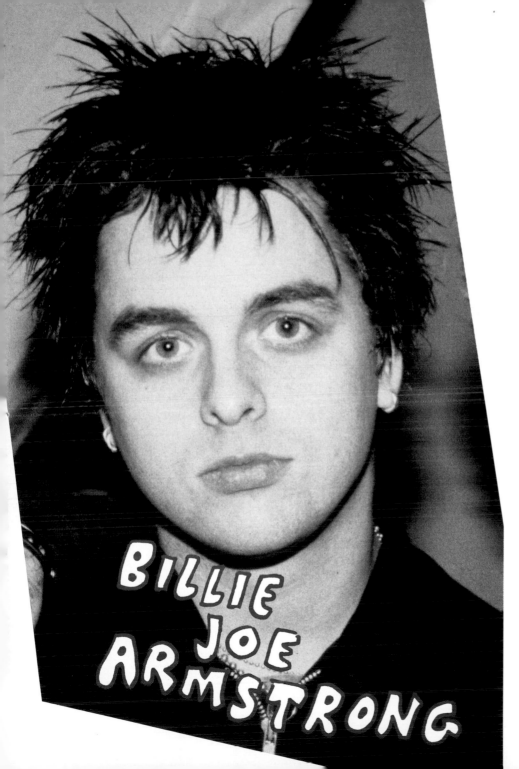

BILLIE JOE ARMSTRONG

TRÉ COOL

Astoria Theatre,
London, England,
February 1, 1998

INTRODUCTION

BY BILLIE JOE ARMSTRONG

We met Bob on the last show of the Dookie tour in 1994. It was the craziest year of our lives and we were exhausted as fuck. The show was kind of a ~~ds~~ fiasco. Bon Jovi, Hole, Weezer, Toad the Wet Sprocket, Sheryl Crow and others. At Madison square Garden. I didn't know if Green Day would ever play MSG ever again so I ~~posted~~ got naked on stage.

Everyone ended up at Don Hills for an after party of sorts. I was drunk on stage singing with Evan Dando, Courtney Love and a bunch of drag queens. We all ended up getting tattoos in the basement. Small needle poke jail style. That's when I got the pachuco cross on my ~~left~~ right hand.

Of course Bob Gruen was there to capture the moment. That's what Bob does with a camera better than anyone else in Rock n Roll. Capturing a rock n roll moment at your best when you're ~~at~~ doing your worst.

ABOVE Mercer Street, NYC, May 16, 2009
OPPOSITE Fuse TV Studio, NYC, November 12, 2005

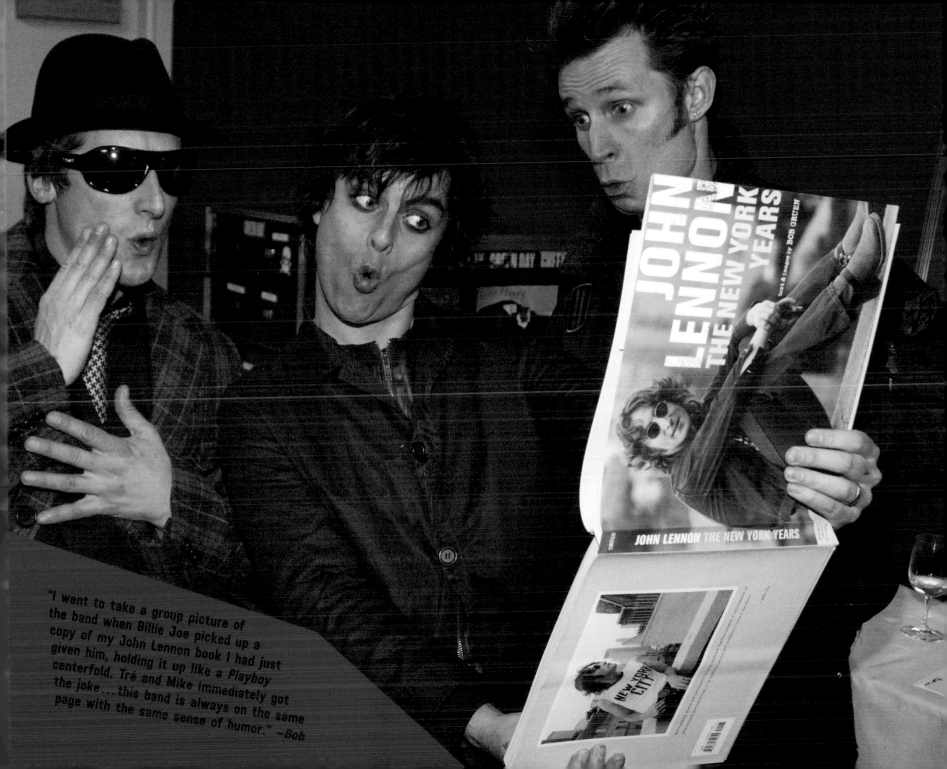

"I went to take a group picture of the band when Billie Joe picked up a copy of my John Lennon book I had just given him, holding it up like a *Playboy* centerfold. Tré and Mike immediately got the joke...this band is always on the same page with the same sense of humor." —Bob

JOHN LENNON THE NEW YORK YEARS

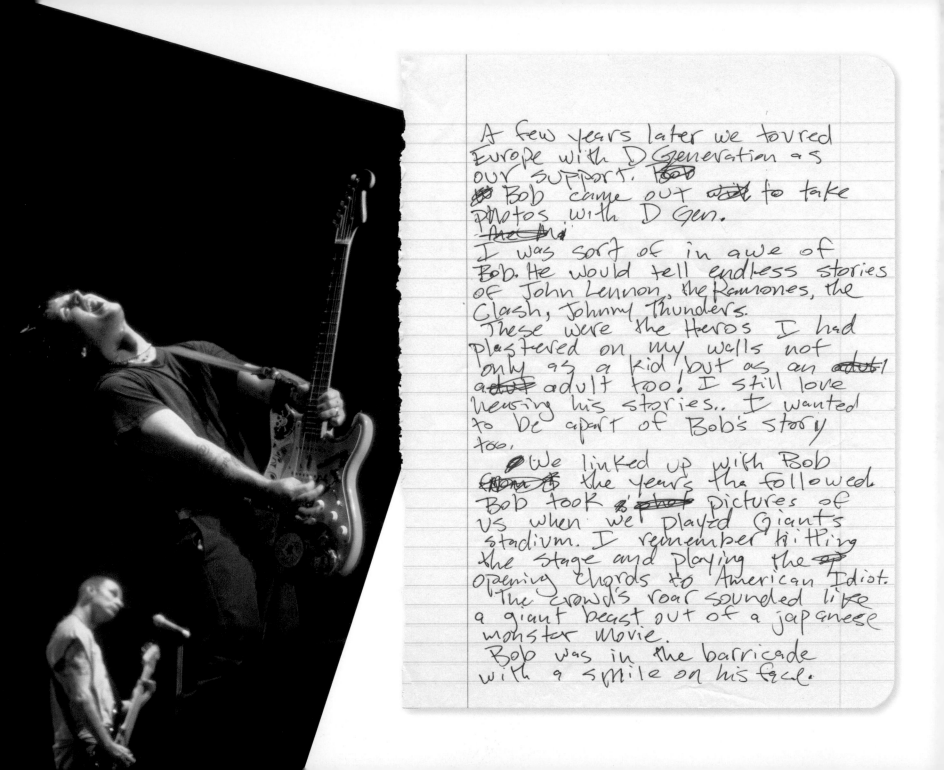

A few years later we toured
Europe with D Generation as
our support. ~~too~~
~~to~~ Bob came out ~~with~~ to take
photos with D Gen.
~~the that~~
I was sort of in awe of
Bob. He would tell endless stories
of John Lennon, the Ramones, the
Clash, Johnny Thunders.
These were the Heros I had
plastered on my walls not
only as a kid, but as an ~~adult~~
a~~dult~~ adult too! I still love
hearing his stories.. I wanted
to be apart of Bob's story
too.

 We linked up with Bob
~~Now is~~ the years tha ~~followed~~
Bob took ~~a~~ ~~that~~ pictures of
us when we played Giants
stadium. I remember hitting
the stage and playing the ~~of~~
opening chords ~~to~~ American Idiot.
The crowd's roar sounded like
a giant beast out of a japanese
monster movie.
 Bob was in the barricade
with a smile on his face.

enjoying the show. Taking photos here and there.

Bob loves rock·n·roll more than anyone I know. ~~He~~ That's why he's such an iconic photographer. He takes pictures of what he loves.

Bob has since become a great friend to us. Taking pictures of us, ~~dinner~~ having dinner and hanging out when we are in New York.

I can't tell you how ~~s~~ fucking special this book is.
For me and ~~for~~ for Green Day.
The company we get to keep is basically my record collection.
Here's to Bob Gruen!
capturing our best!
as we do our worst!

OPPOSITE Astoria Theatre, London, England, February 1, 1998

TOP Bowery Ballroom, NYC, May 18, 2009

BOTTOM Global Citizen Festival, Central Park, NYC, September 23, 2017

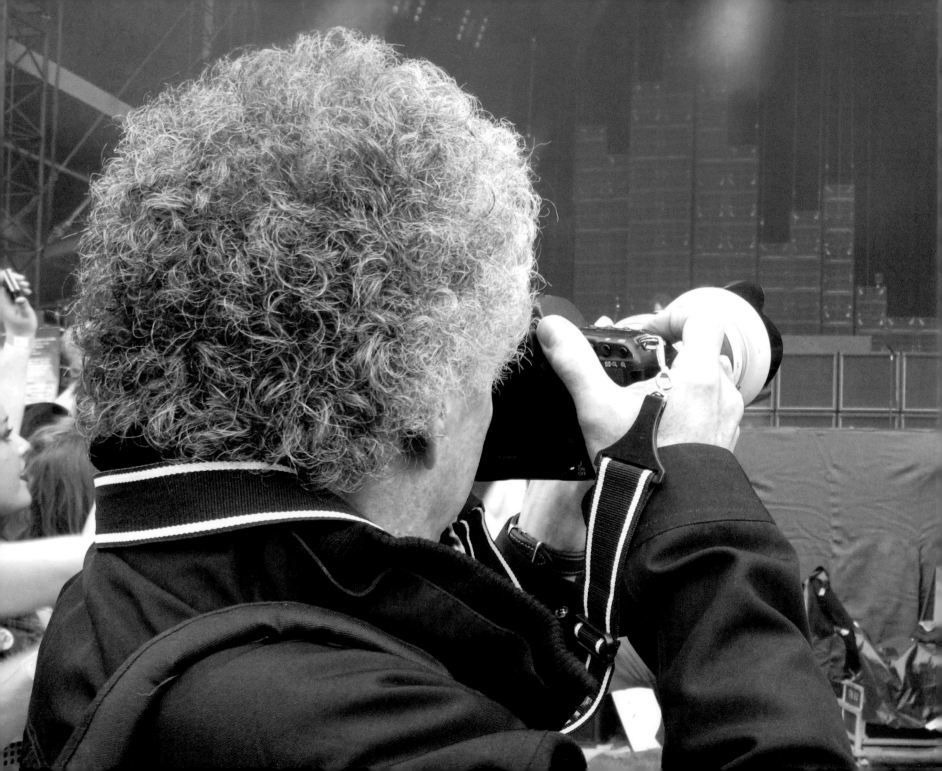

GREEN DAY WAS STARTED BY SOME HIGH SCHOOL KIDS

who wanted to experience as much fun and excitement as possible. They didn't know they would end up spreading their fun around the world. The first time I saw Green Day was on television. It was the summer of 1994, and they were playing at the twenty-fifth anniversary of the Woodstock concert, which was taking place in Saugerties, New York.

It was late on the third day of the festival, and the crowd was pretty rowdy by then, lobbing handfuls of mud at Green Day onstage. Rather than being put off by this, as most bands would be, Green Day got into the game and threw the mud back. Tré Cool even jumped down off the stage to join in the frenzy of the mosh pit. I remember watching and enjoying the chaos—my kind of band, one that knows how to have fun!

A few months later, I saw Billie Joe at a late-night jam at Don Hill's club in SoHo. It wasn't until three years later that I saw the whole band live for the first time, at the release party for their album *Nimrod*, also at Don Hill's. They went on late, after the open bar closed, and it was mayhem. They played their own songs and lots of covers, such as the Who's "My Generation" and Cheap Trick's "Surrender," and I immediately had a new favorite band.

Soon after, my friend Jesse Malin told me that his band D Generation was opening for Green Day on their European tour and encouraged me to come along, so my wife and I joined them for four shows in London and Paris in early 1998. This is when I started to get to know the band and understand their show. I've always been into loud, fast rock & roll, and Green Day delivers! They are exciting to watch and have a great sense of humor.

But what I like most about Green Day is the way they communicate with their audience. At one point in their show, Billie Joe shouts out, "Who can play guitar?" Choosing a lucky fan from the sea of eager waving hands, he brings one of them up onstage, whispers a few words in their ear, hands them his guitar, and gives the kid a chance to show how they can play in front of the whole audience. The first time I saw this, I was stunned. I'd never seen a band do anything like that in the middle of a show—taking a chance and bringing someone onstage from the audience to play with them.

Bob Gruen and Billie Joe Armstrong,
Marlay Park, Dublin, Ireland, June 23, 2010

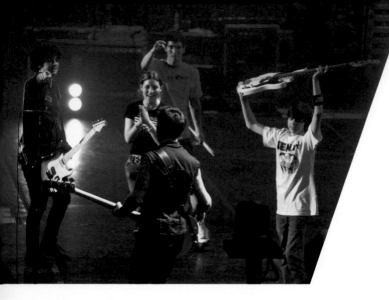

Madison Square Garden, NYC, July 28, 2009

The St. James Theatre, NYC, February 24, 2011

It turns out that they do this at every show. And it's a tremendously inspirational moment for the whole audience, letting them see that any one of them could be the rock star. For a couple of years, they even brought up a drummer and a bass player and basically showed the audience how to form a rock & roll band with three chords and a drum.

The more I got to know the band the more I liked them. They are very upbeat people, always cracking jokes. I went to see them whenever I could. Fortunately, it turned out that as I was becoming a fan of Green Day they were already fans of my photos and were happy to have me come around to take pictures, giving me access on- and offstage. They were familiar with the work I had done with the English punk bands, particularly the Clash, and we shared the feeling that the Clash were the "only band that really mattered," as Clash fans like to say. But I felt that Green Day also mattered in a big way. Like the Clash, they were known to make powerful statements about social issues, especially with songs like "Minority," "Know Your Enemy," and "American Idiot."

When they came to play New Jersey's Giants Stadium in 2005, it was the first time I was invited backstage to photograph them in their dressing room. I felt privileged—they have tight security with no guests allowed backstage or in their dressing room. They even have a separate room for family members. I was given access to photograph the entire show from anywhere, including on the side of the stage. This is rare, as most bands are very restrictive with giving out photo passes.

I never worked for or was hired by Green Day, nor was I ever on assignment for a magazine. I went to see and take pictures of them because I wanted to, and they liked having me there. Hanging with Green Day is always fun. They may have become successful, but they never stray far from their street roots. They're constant pranksters—always joking around—and I really enjoy being with them.

When I met Green Day, they were already playing theaters and bigger venues. But I got a taste of what the early club-date years were like when I went to their Foxboro Hot Tubs shows...when these guys let off steam, the room gets very steamy. Foxboro Hot Tubs is Green Day's alter ego. They use this name when they play somewhat secret shows in small clubs. In New York, they played Don Hill's Club and Jesse Malin's Bowery Electric Club, both of which hold only about 200 people. I like the idea that one day they're playing a large stadium and the next a small, hot, crowded space. This brings them back to the feeling of their punk roots. (Billie Joe told me that they were once asked to perform at an apartment party that was so crowded they had to set up and play in the bathroom!) A critic once accused Green Day of selling out because they were now playing big arenas. Billie Joe's response was "Is it wrong that we're so good that thousands of people want to see us?" But playing as Foxboro Hot Tubs in small clubs, with the audience up close and personal, helps them stay in touch.

I've been a fan of Green Day ever since I first saw them, and twenty-five years after I took my first pictures of the band, it's high time to gather them in a book and make it available to all of their other fans. I hope you enjoy this collection and continue to be part of the excitement that is Green Day.

Bob Gruen
February 2019
New York City

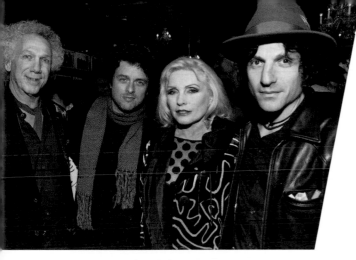

Bob Gruen, Billie Joe Armstrong,
Debbie Harry, and Jesse Malin during
Bob's 68th birthday party, R Bar, NYC,
October 23, 2013 PHOTO BY DAVID APPEL

Jesse Malin and Billie Joe Armstrong during
a 2 AM recording session, Stratosphere Sound,
NYC, March 30, 2009

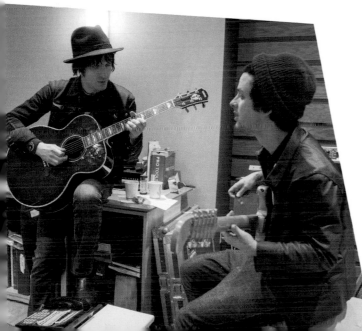

I FIRST SAW GREEN DAY

in the summer of 1992 at the Hollywood Palladium with my buddy Joe Sib. It was at a time when a lot of bands were grunged out, looking down at their feet with hair in their faces, playing long songs with slow tempos. We needed something new and fresh. Then, out came these three guys; full-on, in-your-face, pointed, full of energy, attitude . . . and the songs were great. And they were just the opening act. I went back to New York and told the guys in my band, D Generation, about them.

Next thing I knew we were opening on their US tour. We had opened for lots of bands before, but were never treated like this. The Green Day guys shared everything they had with us. They had a great sense of humor, like the Marx Brothers with guitars. They loved pranks, chaos, messing with anyone and anything. But it was very clear that they loved their fans. We traded bootleg cassettes, they shared their gear, we sang Irish folk songs, and went our merry way from town to town. Watching them on stage every night, you could see they gave every ounce, and, to this day, they are still one of the strongest and most consistent live bands you'll ever see.

When we were invited to do their European tour in 1998, I asked my friend Bob Gruen, the photographer, and his wife, Elizabeth, if they wanted to join us on our international pirate ship (aka: UK tour bus). As kids, we grew up surrounded by Bob's photos, and now he was at our shows taking pictures. It was surreal. We found out quickly that he was the real deal. He was still out every night, going to gigs, there on the frontline. Bob lived and breathed it. He photographed everyone from Lennon to the Clash, and if he backed your band, it was beyond a huge compliment.

I knew the Green Day guys would love him, and, after one long, late night in London, they all became fast friends. Green Day gave Bob an all-access pass to their lives as real people, not just rock stars. They felt comfortable having him in their dressing rooms and on their stages. Sick, tired, sober, drunk, winning awards, falling in love, and always bringing down the house. Bob was there to capture it all.

It's been amazing to watch Green Day become one of the biggest bands in the world, using powerful songs to speak up in troubled times when not many major artists would dare to. Creating the first punk rock opera. Taking over Broadway and turning a fancy theater into a fucked-up, wild funhouse. Winning Tonys and Grammys and entering the Rock & Roll Hall of Fame. Forming power-pop side projects, playing surprise shows in little clubs, smashing up their gear with huge smiles. Empowering young kids, letting them know that they are not alone, and that it's okay to be themselves.

A real group, in its truest sense, is a gang, a family, a lifestyle, where each member adds their own power and personality to the greater sum. Bands like Green Day don't come around that often. It's really wonderful to look back at all these images from the last twenty-five years. Bob's photos capture a sound and an urgency that can't be denied. You can hear the music burning off the pages, smell the smoke, taste the sweat, feel the heat and the power in your heart, like you are right there tearing it up in the pit.

Jesse Malin
February 2019
New York City

"Fun night! Everyone got a
tattoo in the basement." –Billie Joe

Evan Dando,
Billie Joe
Armstrong,
Mistress
Formika, and
Courtney Love.
Don Hill's, NYC,
December 5, 1994

"Don Hill's embodies our New York club show experiences."
—*Green Day*

Record release party for
Nimrod, Don Hill's, NYC,
October 1997

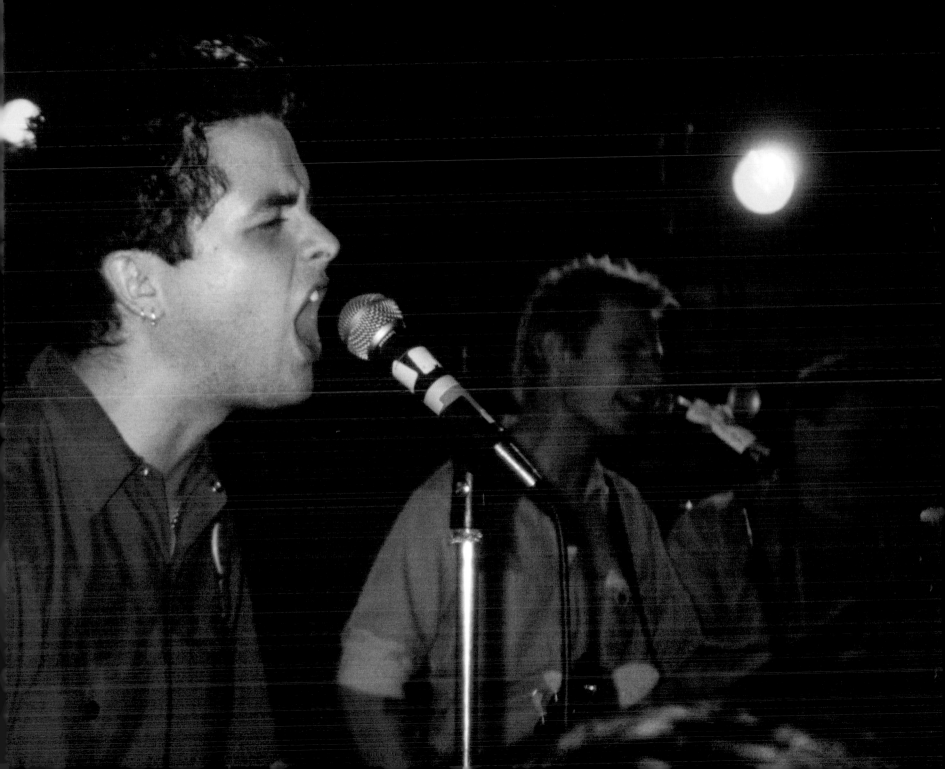

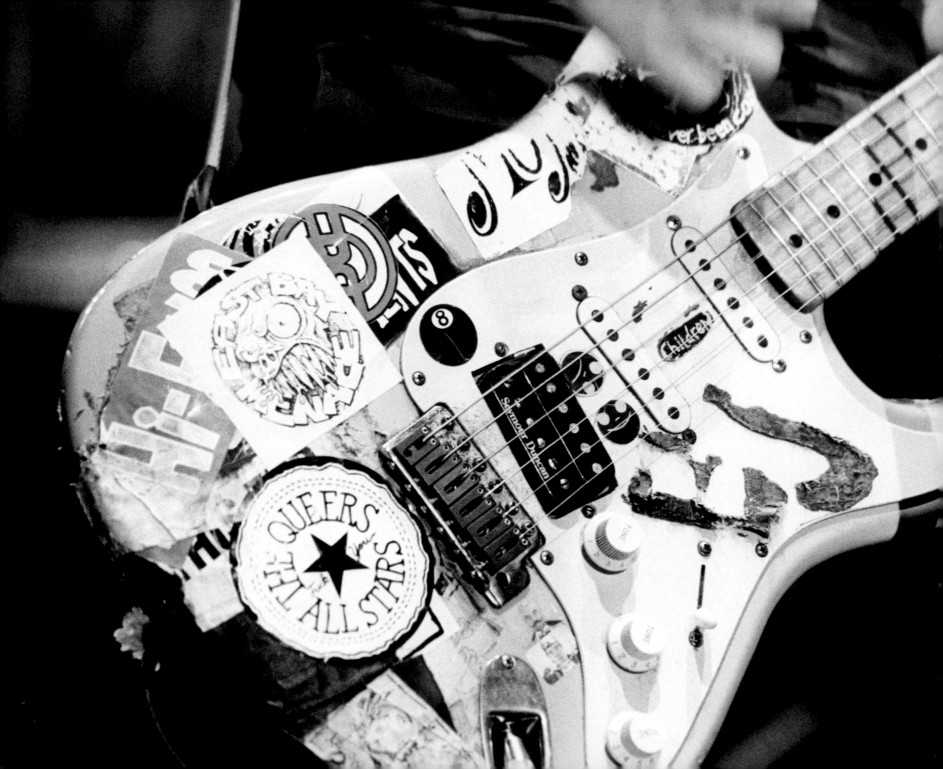

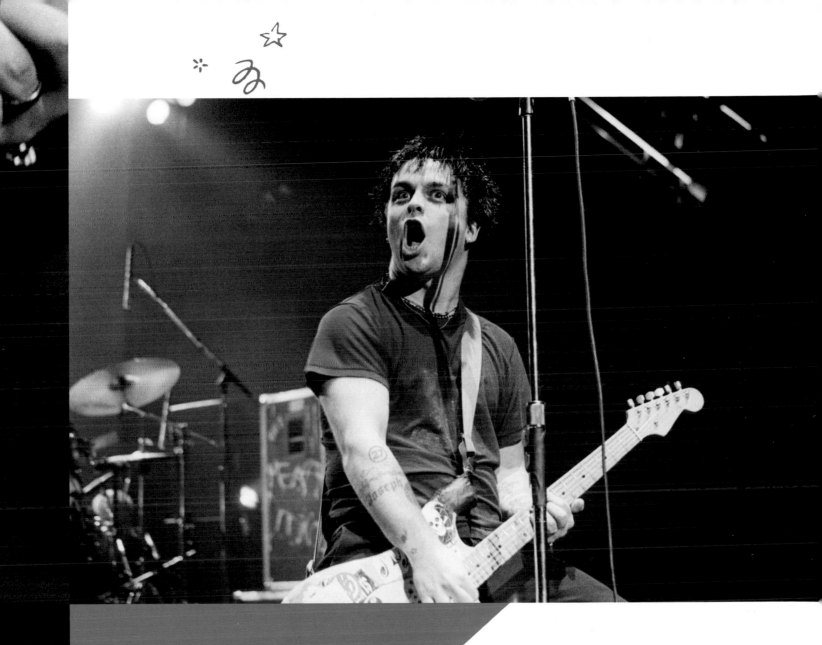

THIS SPREAD AND PAGES 22–23
Brixton Academy, London, England, January 30, 1998

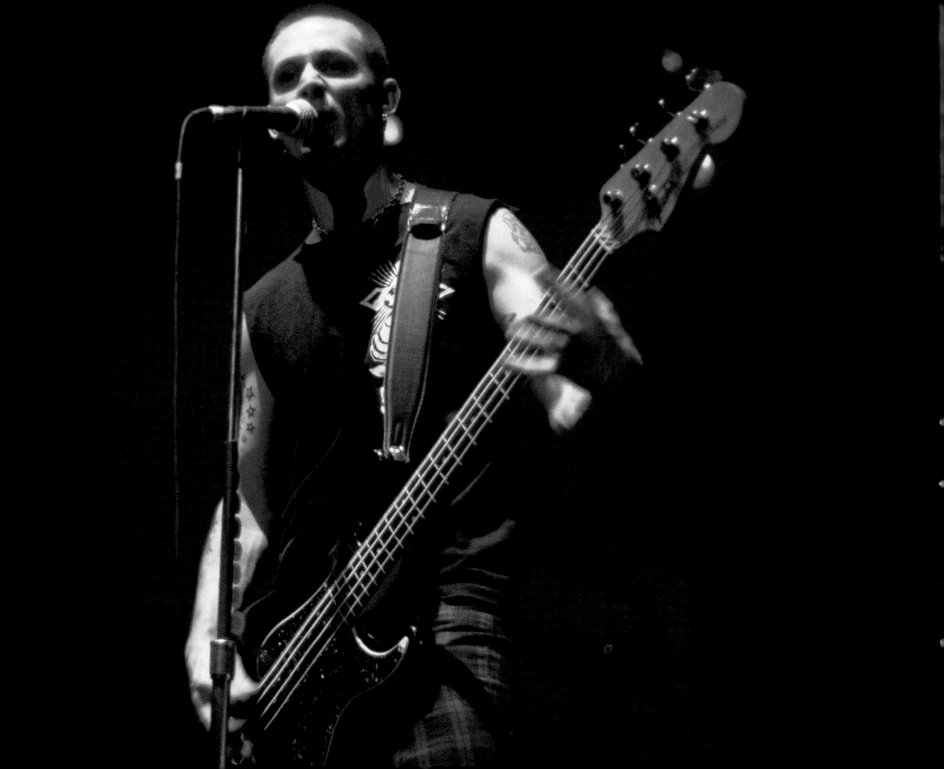

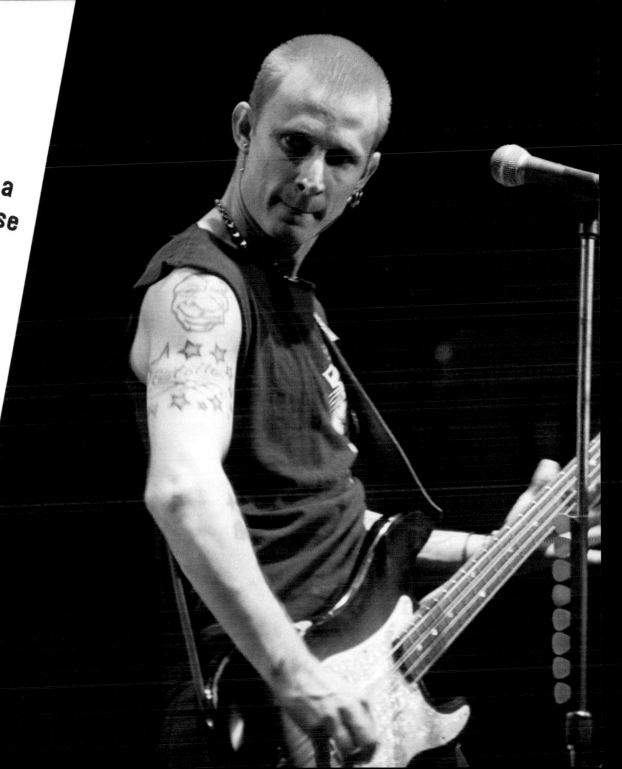

"Mike has a
unique sense
of style;
his hair is
a different
color every
time I see
him." —Bob

"These were
my kung fu
years." —Mike

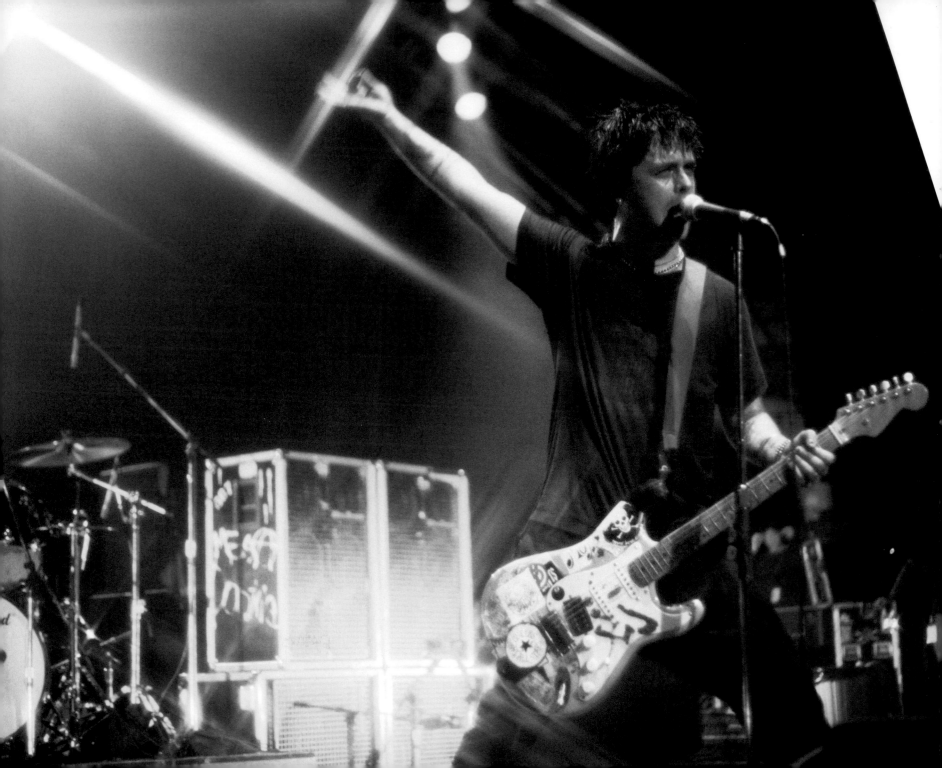

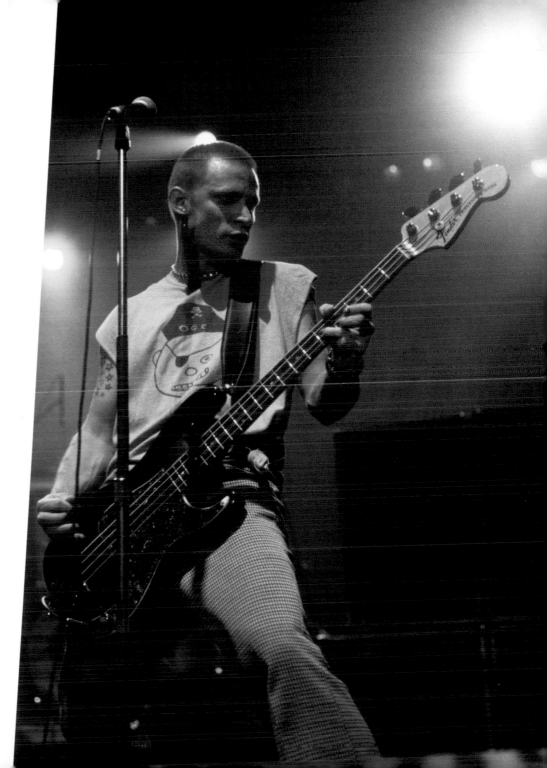

"I stole this shirt from a band in the UK."
—Mike

"Me watching the master at work!"
—Mike

Green D

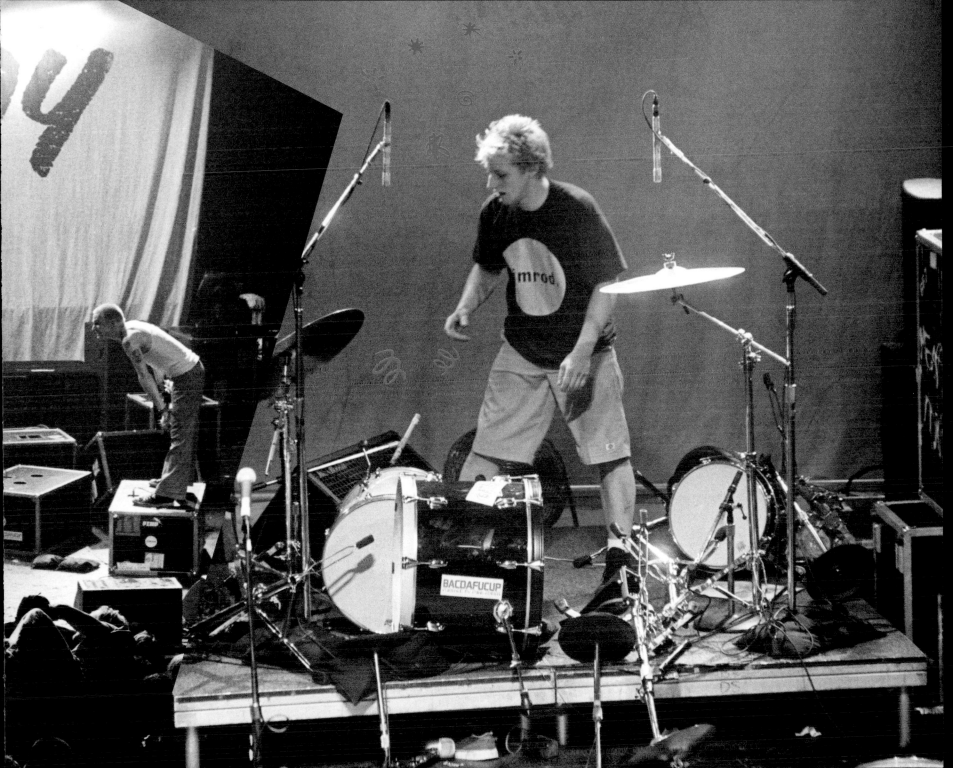

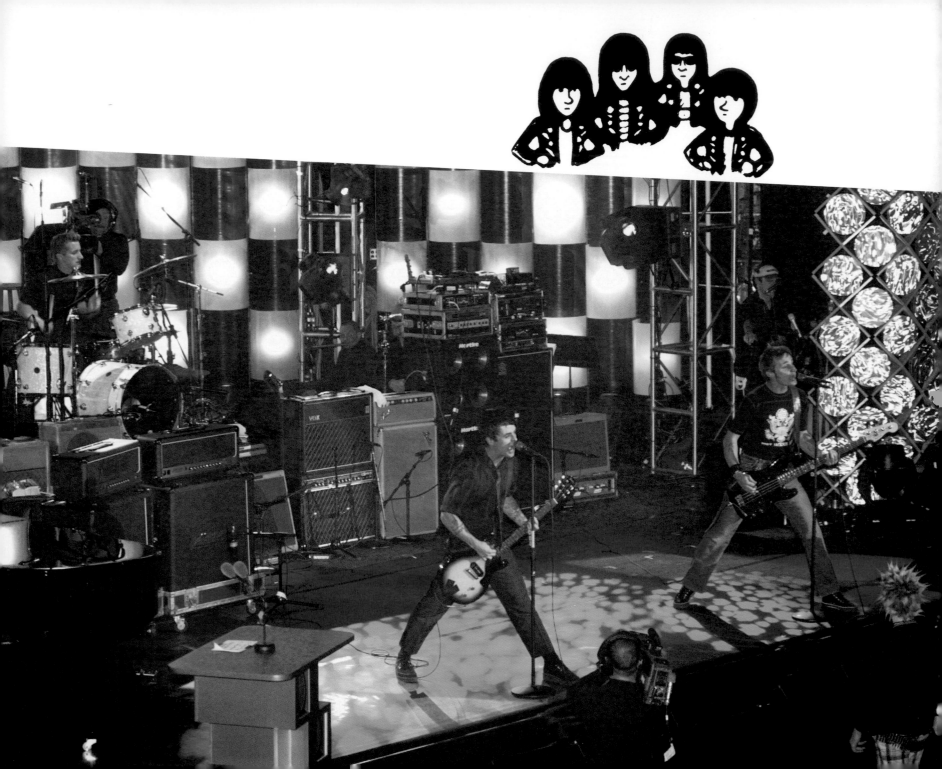

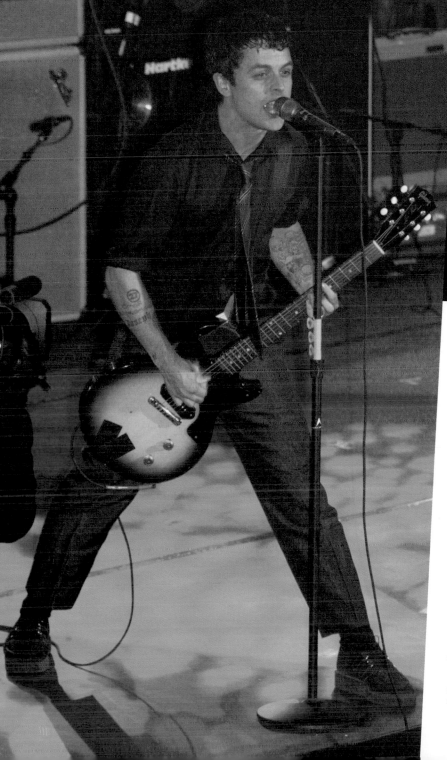

"I'll always remember
this night. I got stuck
in an elevator with
Dee Dee Ramone!"
—Billie Joe

With Kate Pierson of the B-52's,
Rock & Roll Hall of Fame Induction
Ceremony for the Ramones,
Waldorf-Astoria, NYC, March 18, 2002

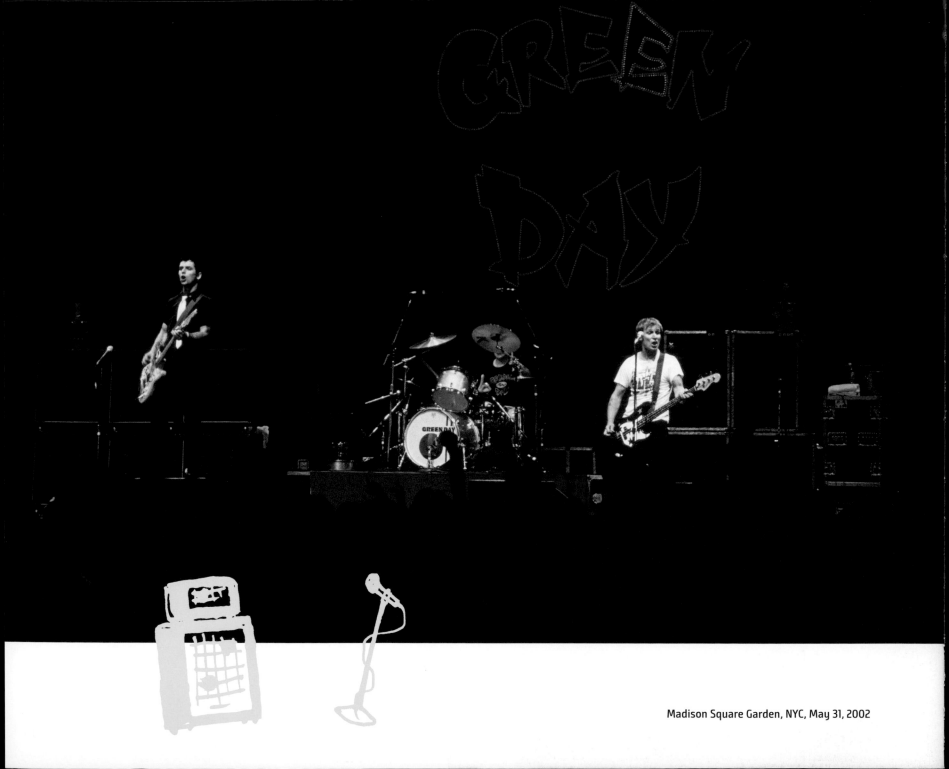

Madison Square Garden, NYC, May 31, 2002

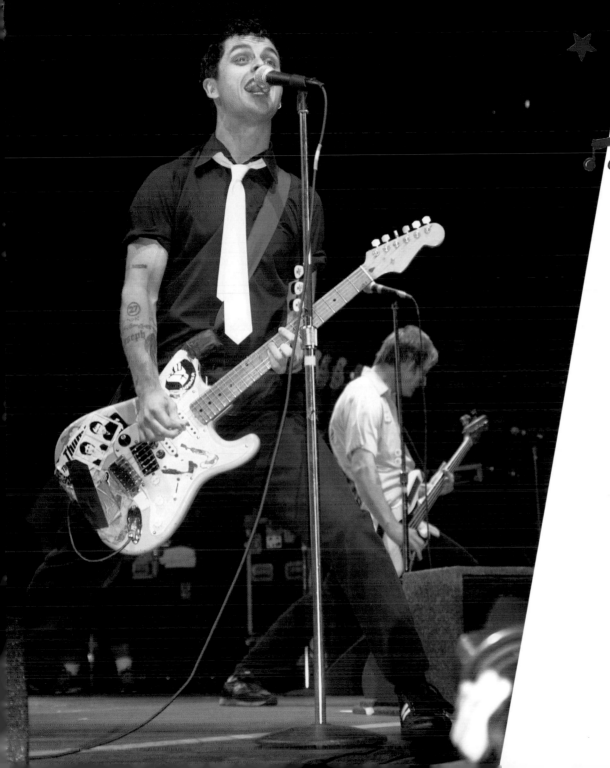

"Suddenly I'm
hungry for
Chinese food."
—*Billie Joe*

"Authorities closed off an entire city block near Wall Street for an after-work Green Day party."
—Bob

"This was a free pop-up show we played on the release day of American Idiot."
—Green Day

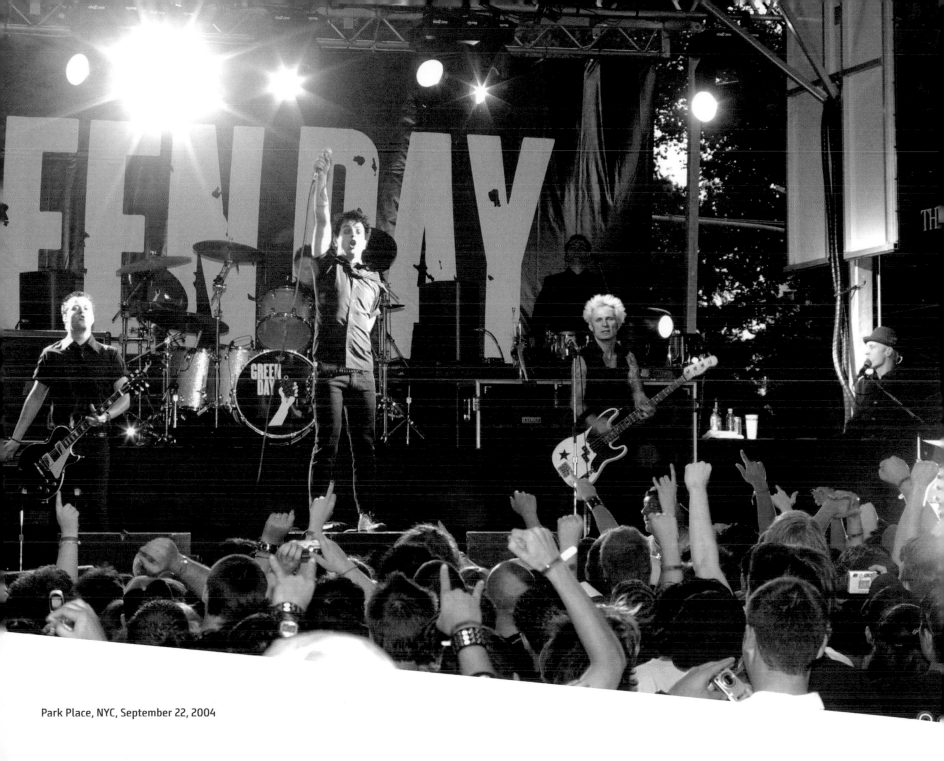

Park Place, NYC, September 22, 2004

"BOULEVARD OF BROKEN DREAMS"

Lower East Side, NYC, January 6 , 2005

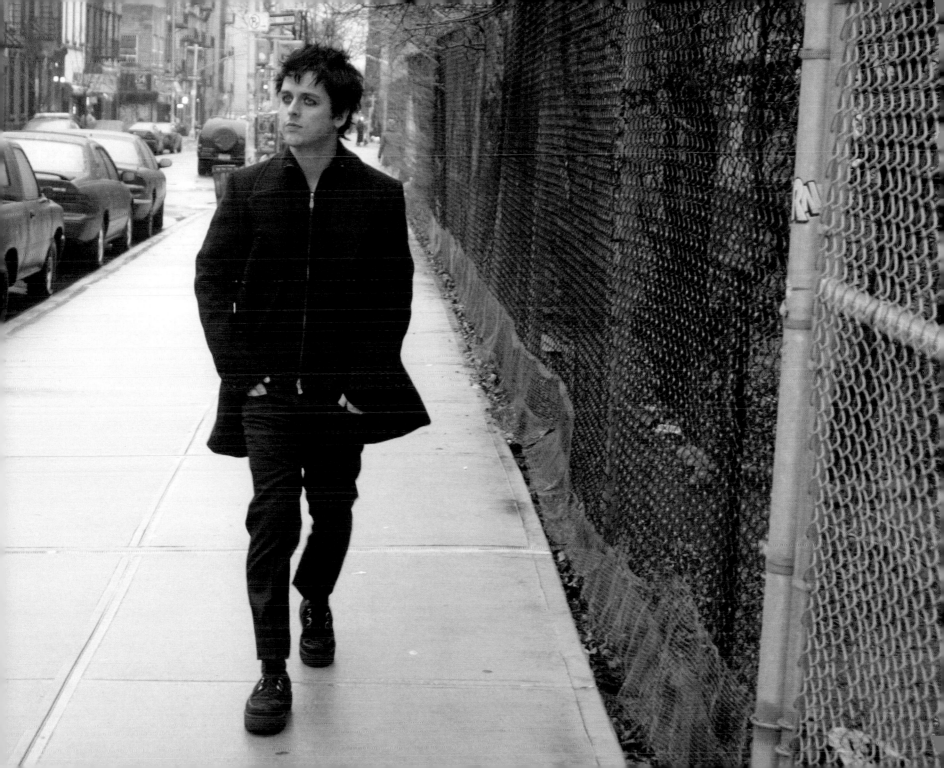

Billie Joe Armstrong

Jason White

Ron Blake

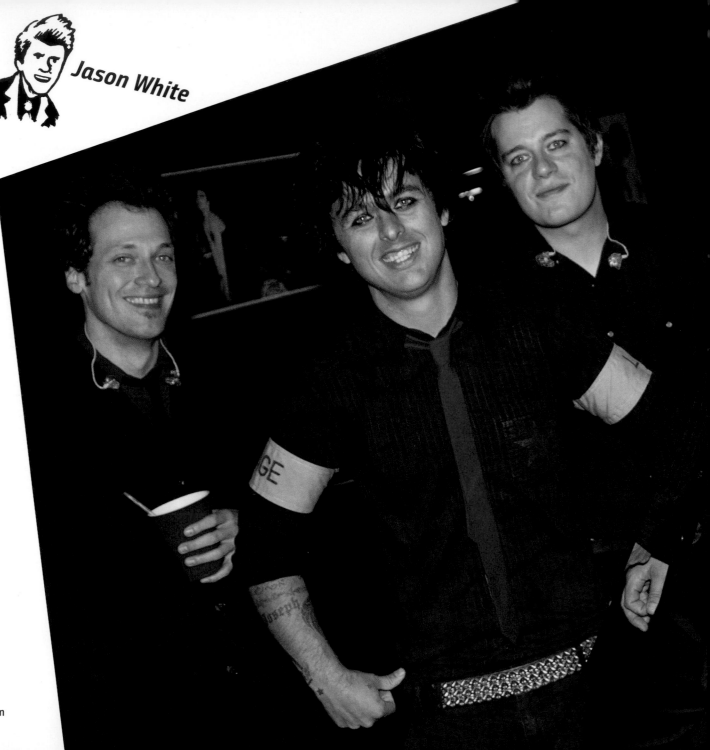

Jeff Matika
(JOINS IN 2009)

Backstage before show at
Giants Stadium, East Rutherford,
New Jersey, September 1, 2005

PAGES 38–41 Onstage at Giants Stadium

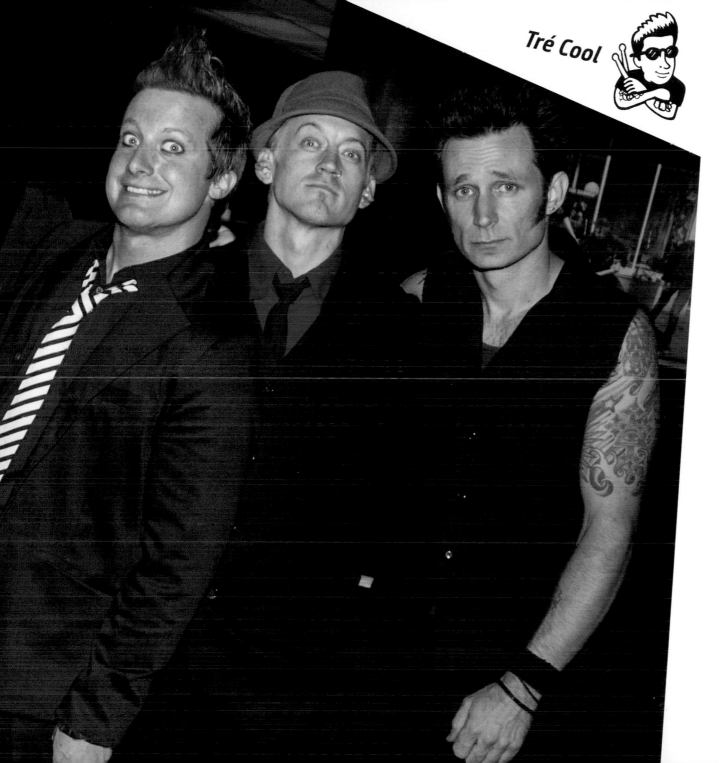

Tré Cool

Jason Freese

Mike Dirnt

"I had just thrown up— this was Green Day's first stadium show in America."
—Mike

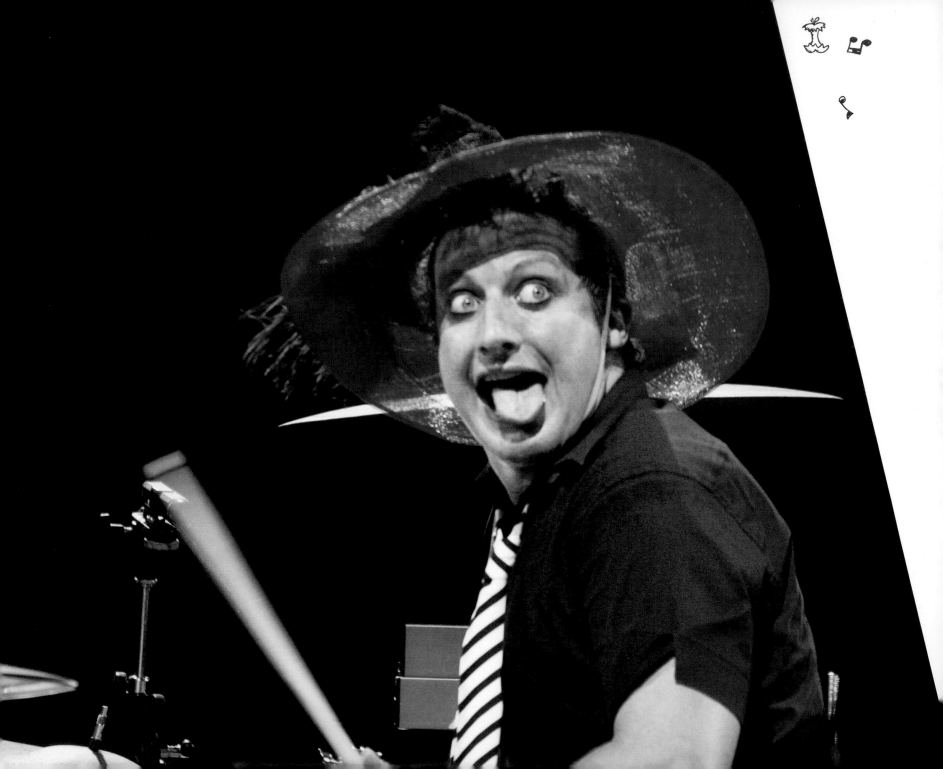

"To stay young looking,
Tré Cool recommends
a hot iron to the face
twice a day."
—*Tré*

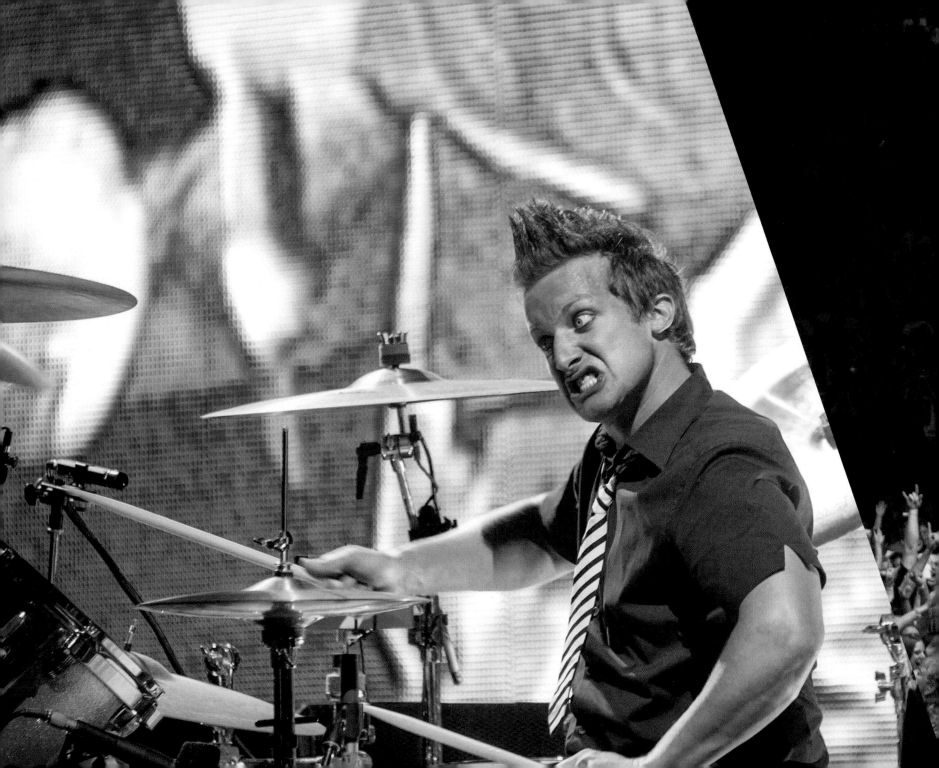

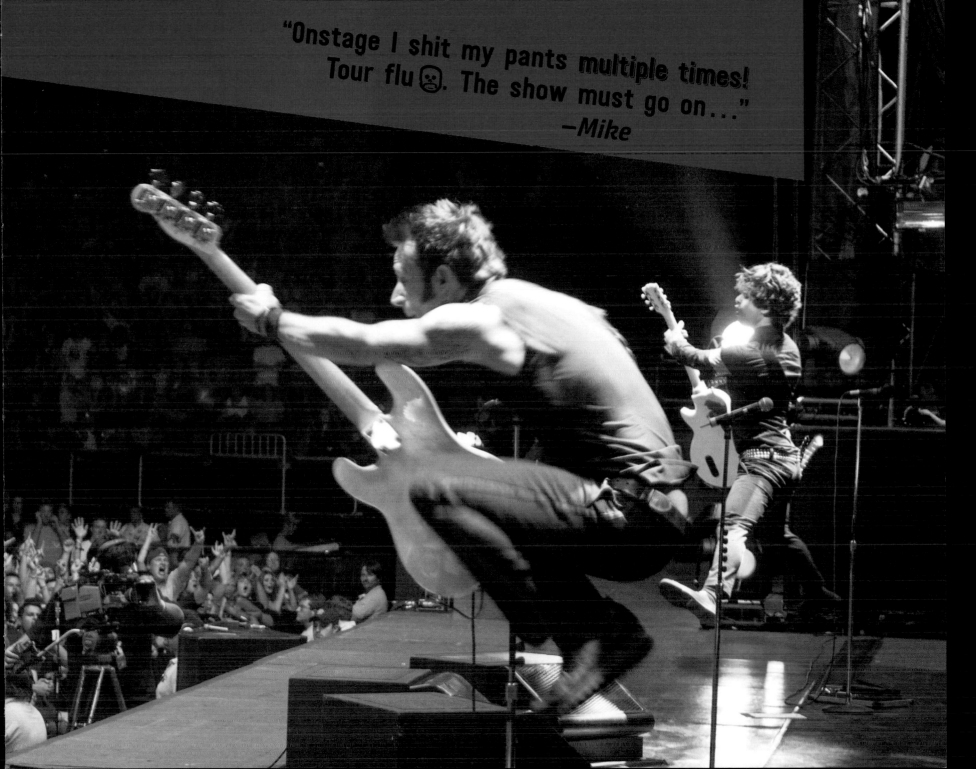

"Onstage I shit my pants multiple times! Tour flu☹. The show must go on..."
—Mike

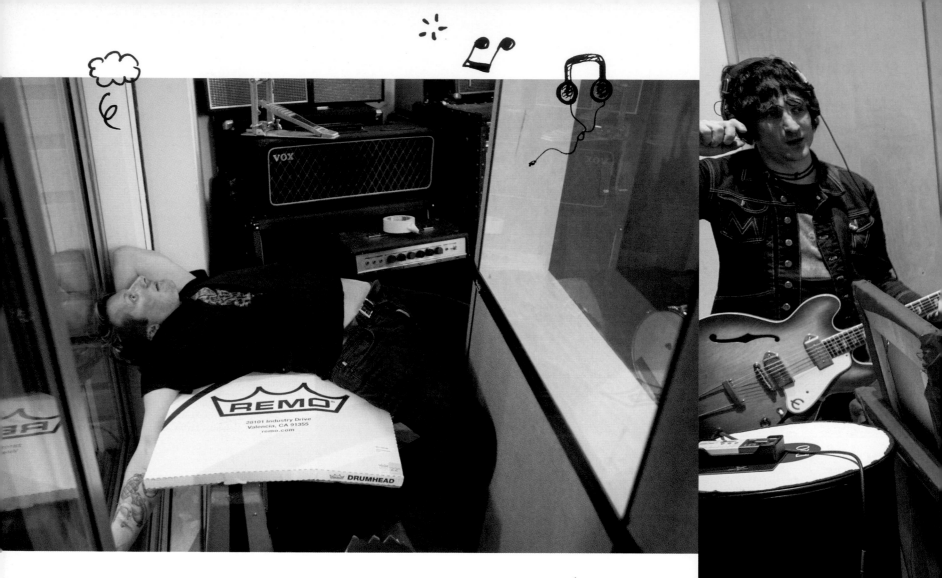

"The Rodeo Queens! I can't believe we are standing. How dry we were." —*Billie Joe*

With Jesse Malin,
Stratosphere Sound, NYC,
March 30, 2009

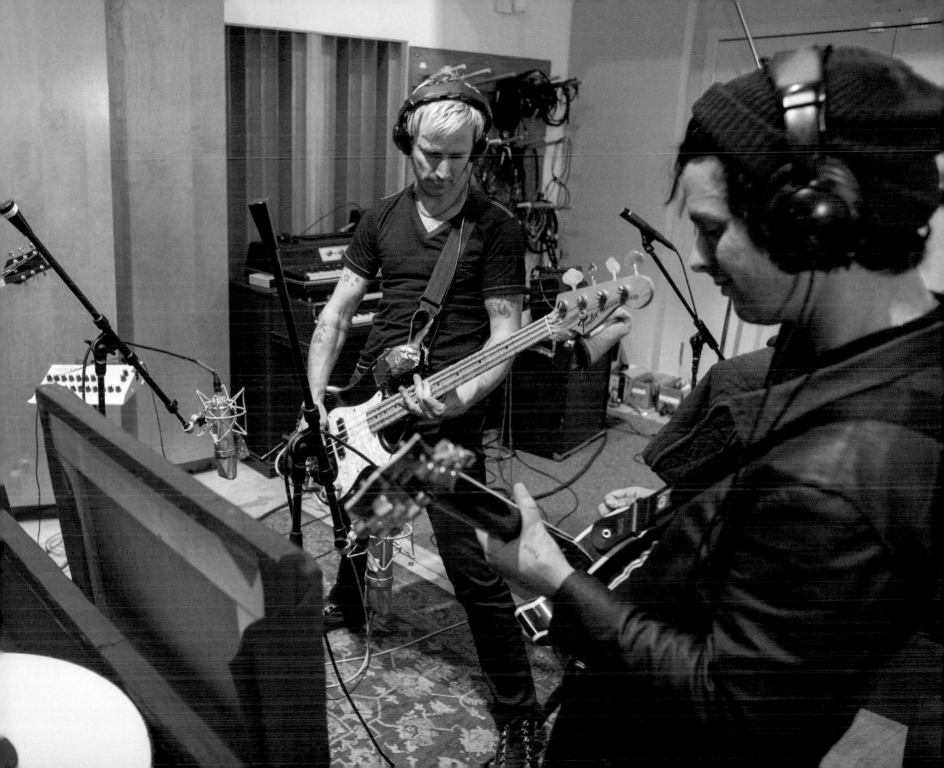

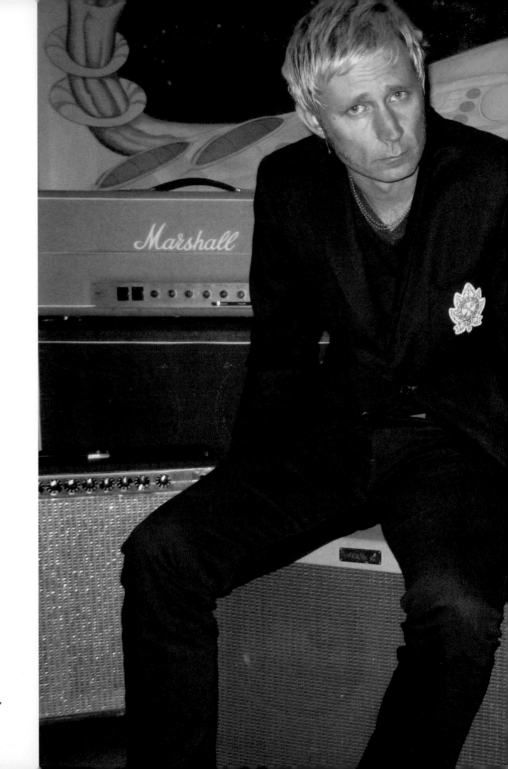

Electric Lady Studios, NYC,
March 31, 2009

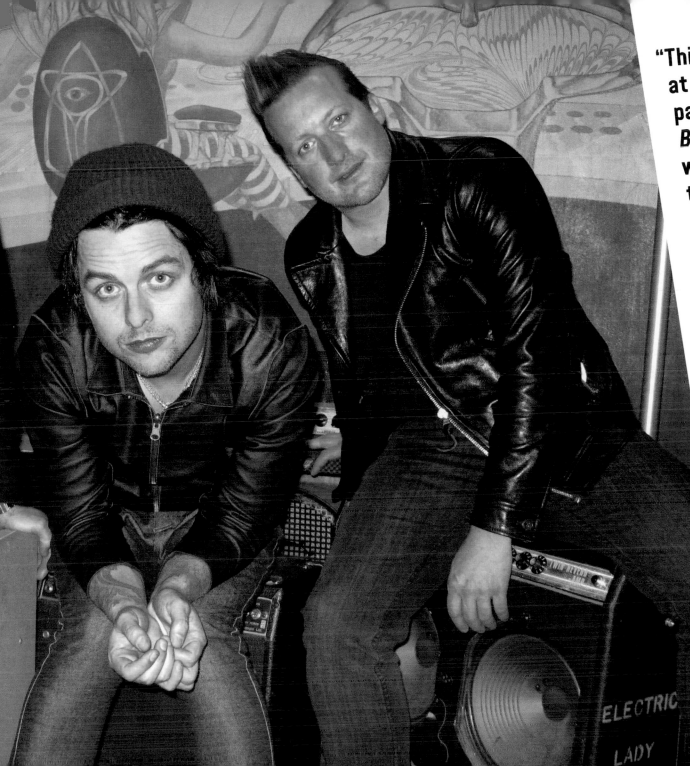

"This photo was taken at our first listening party for *21st Century Breakdown*. Bob was there to take this—we were so drunk and happy we ended up jamming all night and started a band with Jesse Malin called the Rodeo Queens."
—*Billie Joe*

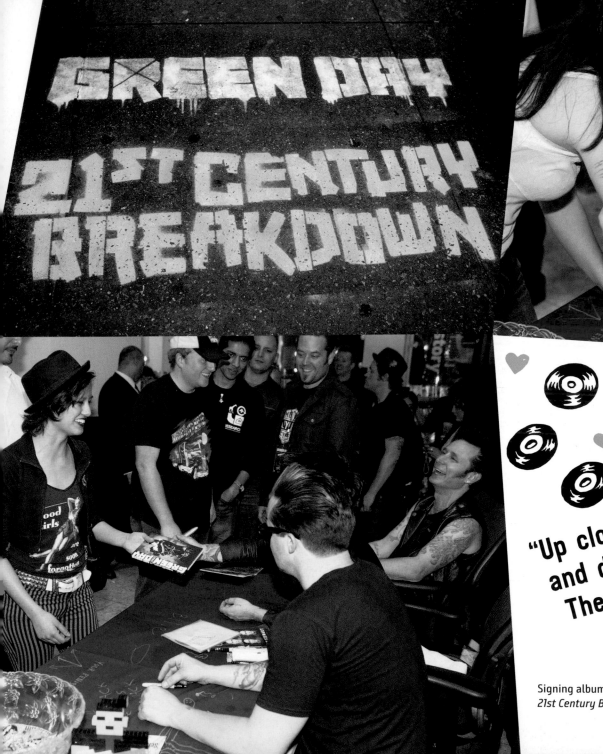

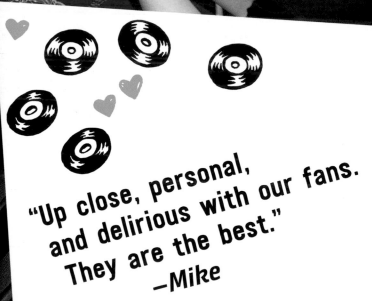

"Up close, personal, and delirious with our fans. They are the best."
—Mike

Signing albums (and arms!) for the release of
21st Century Breakdown, Best Buy, NYC, May 15, 2009

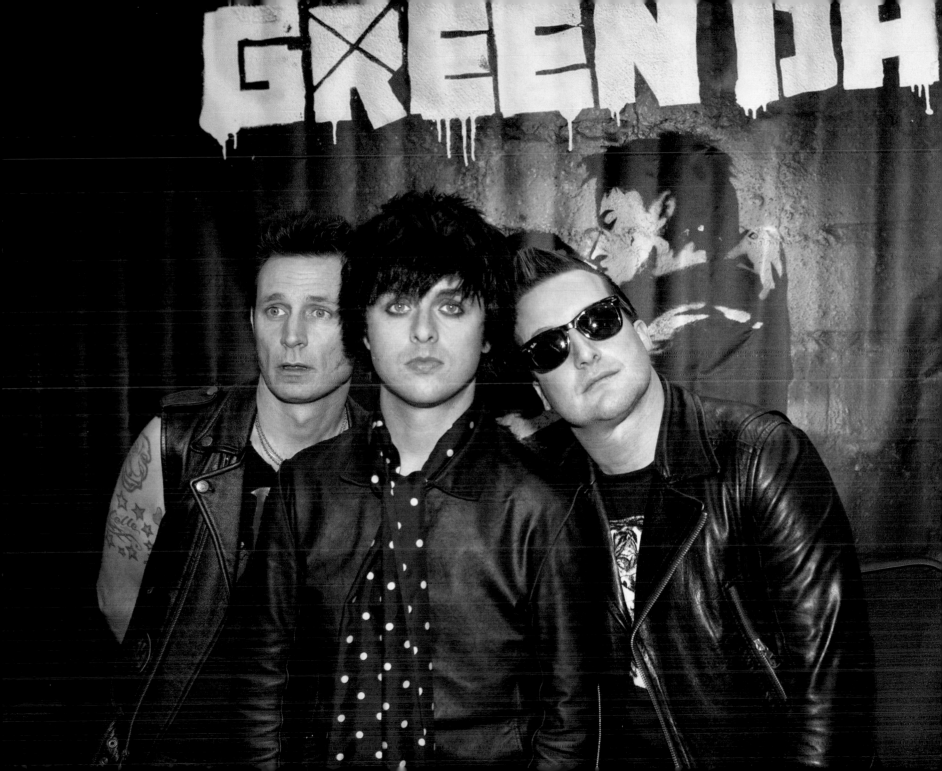

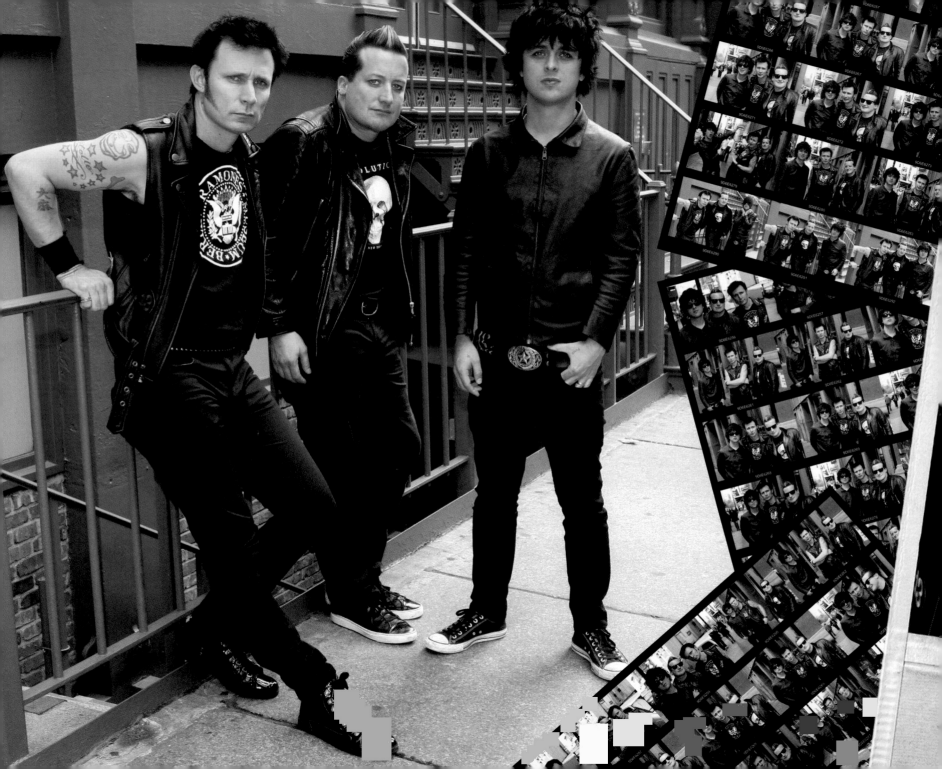

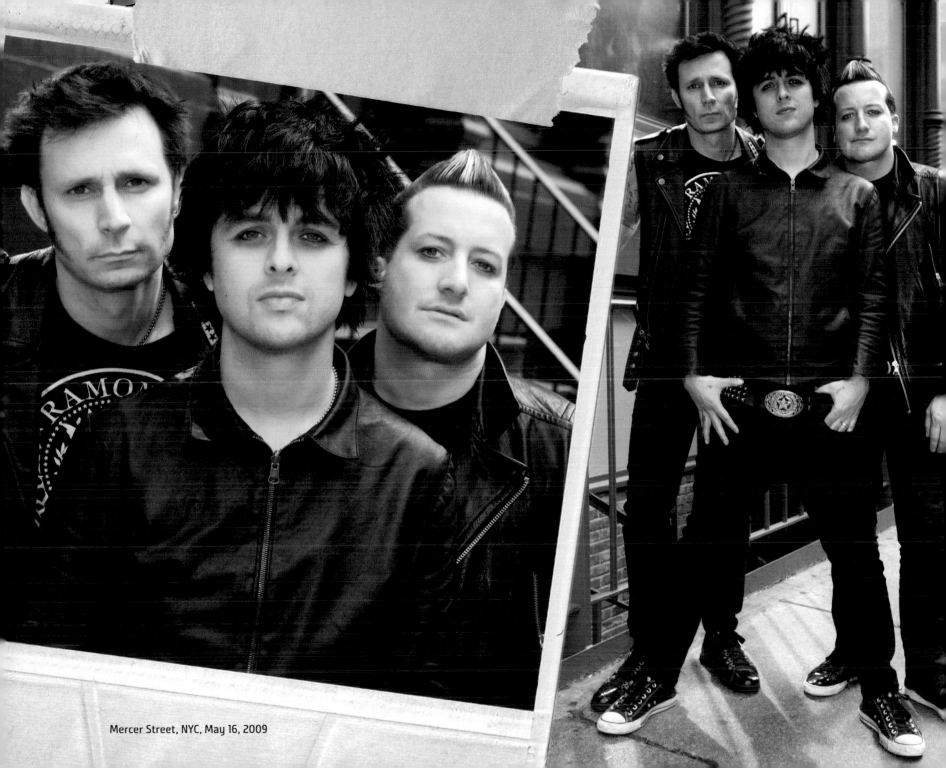

Mercer Street, NYC, May 16, 2009

NEW YORK CITY

"John Lennon, Joe Strummer,
Green Day...thanks, Bob!"
—Billie Joe

"Green Day in the same place where
I photographed the Clash in 1981." —Bob

Rockefeller Center, NYC, May 16, 2009

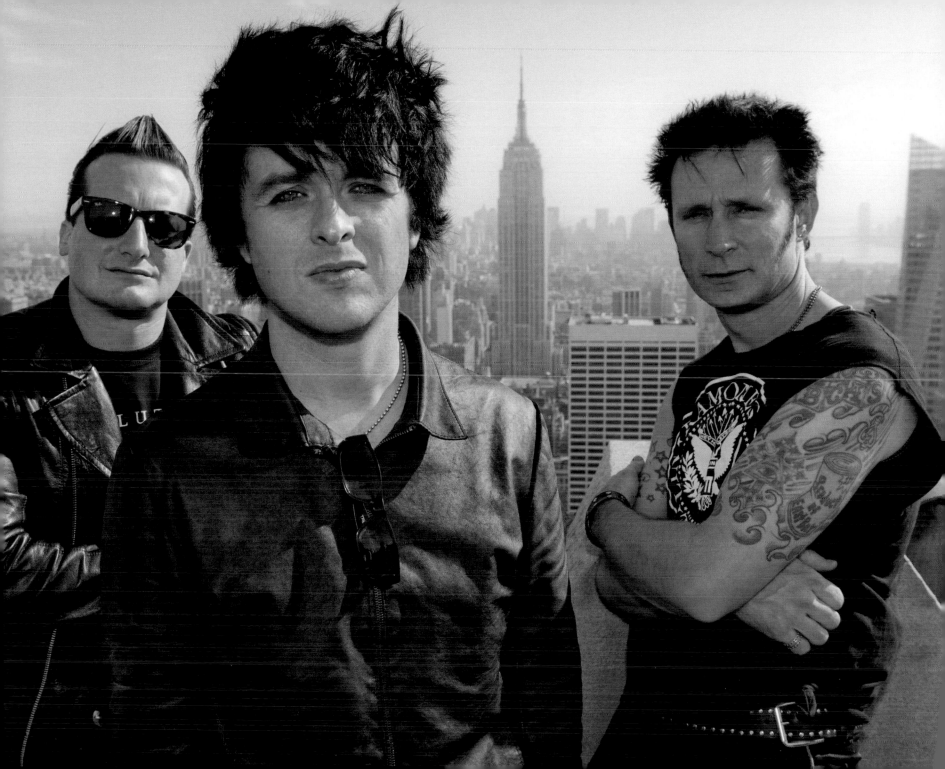

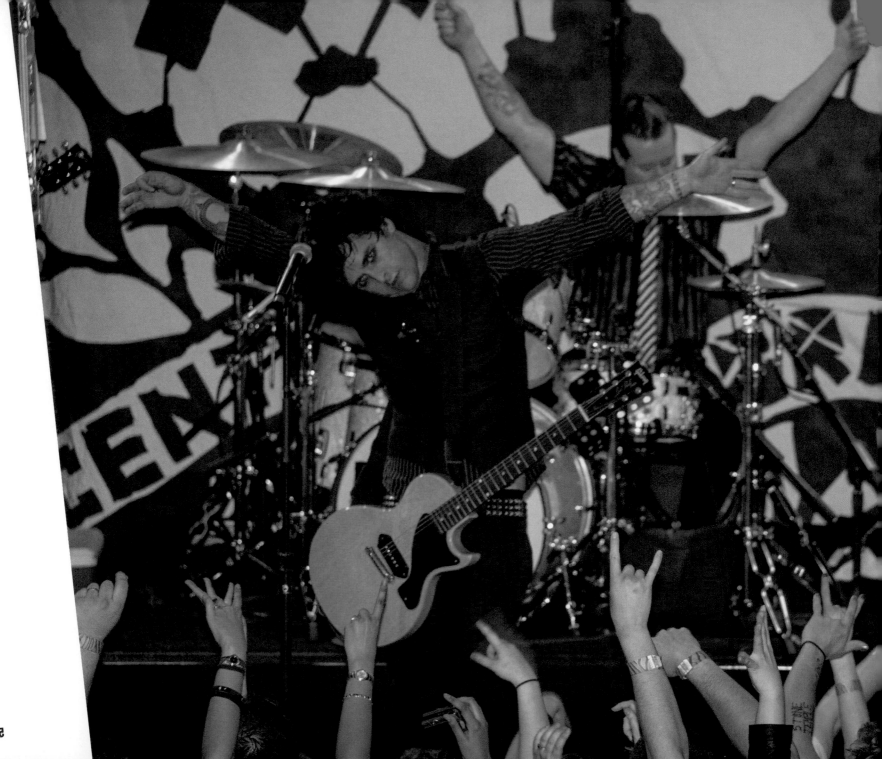

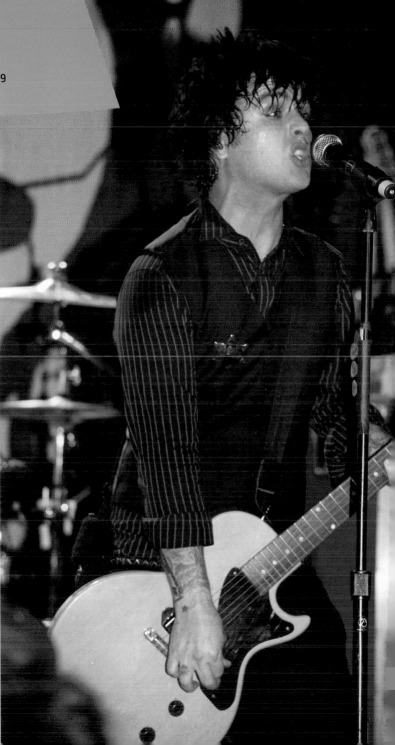

Bowery Ballroom, NYC, May 18, 2009

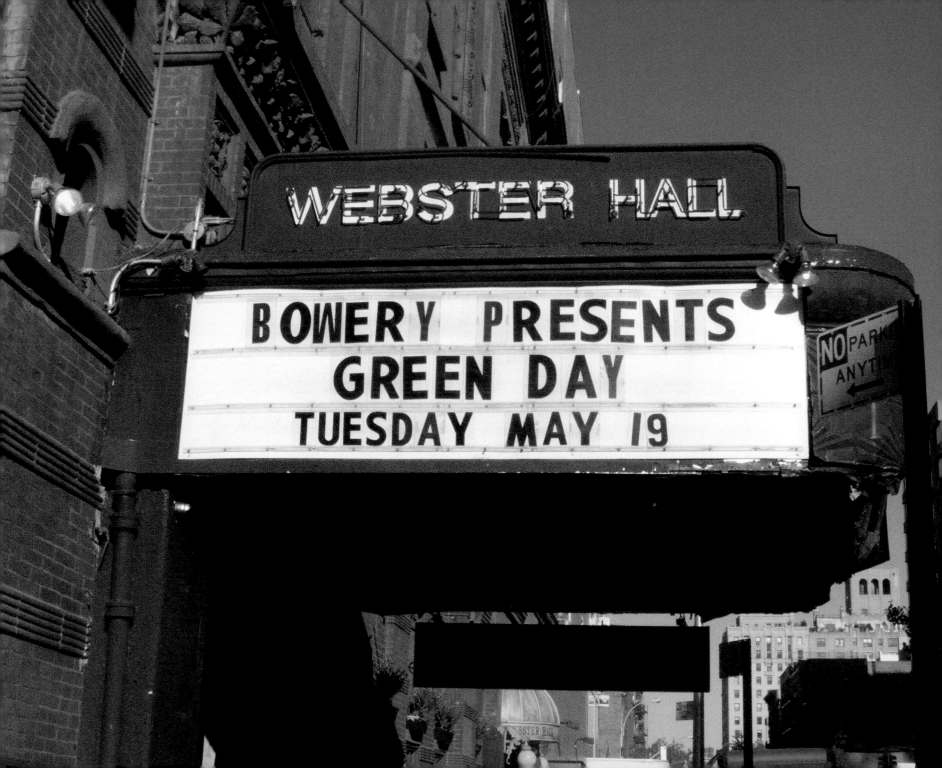

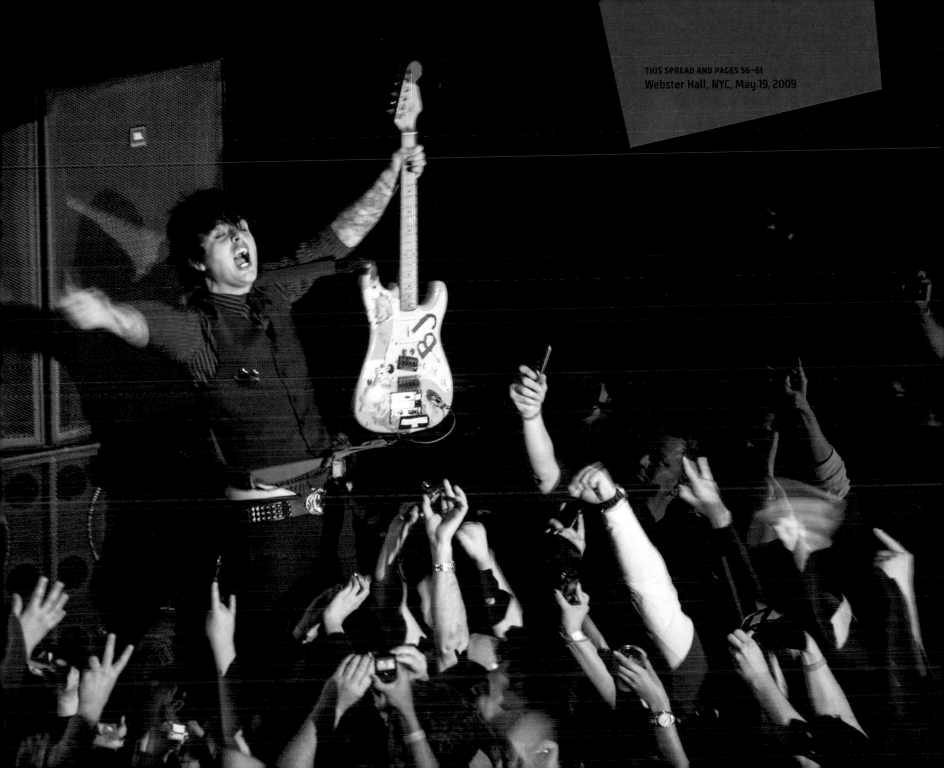

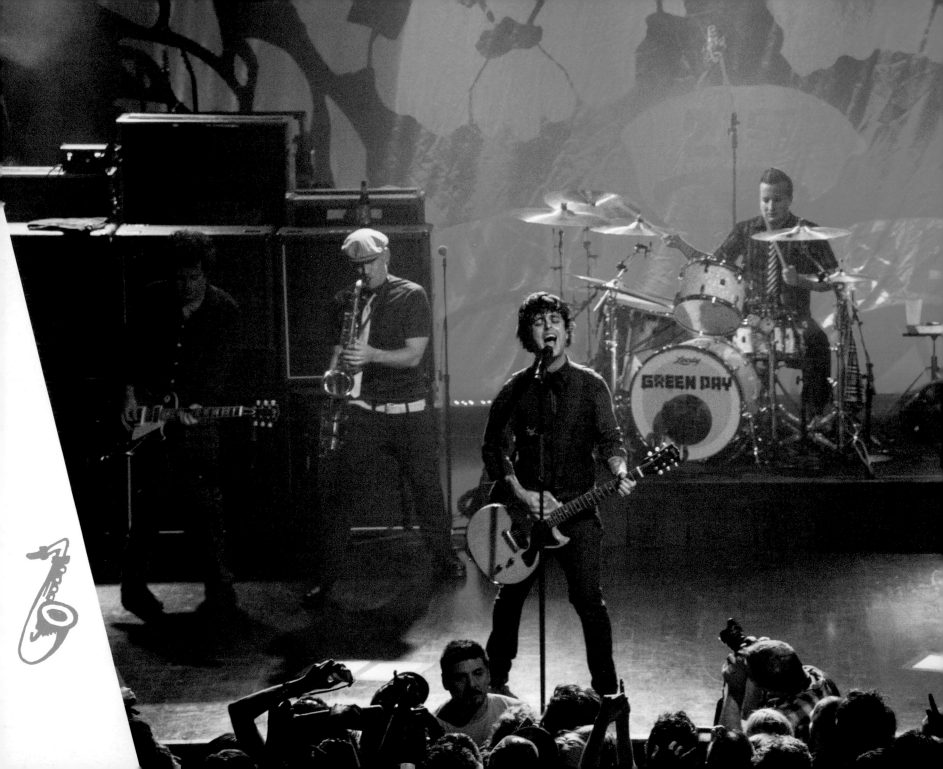

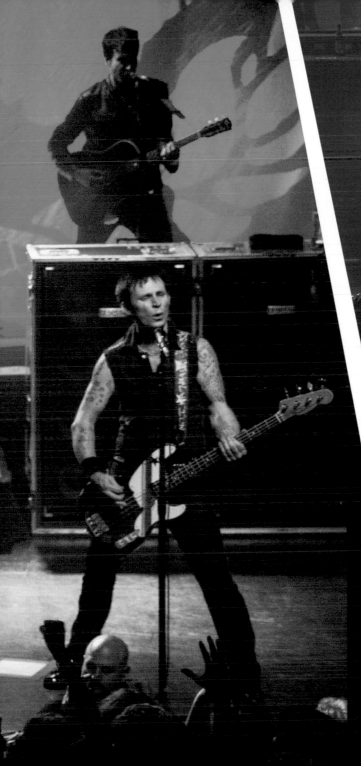

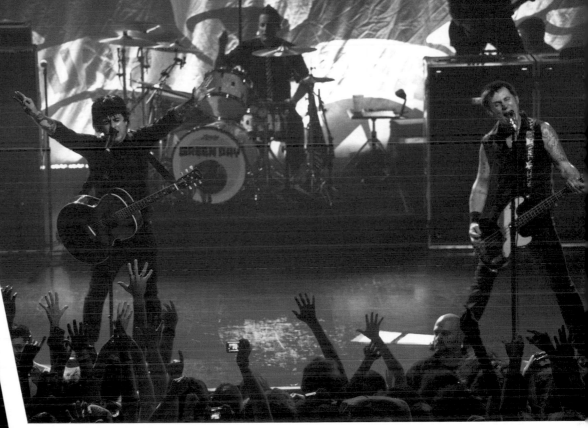

"The floor was moving so much,
we thought it would cave in."
—Green Day

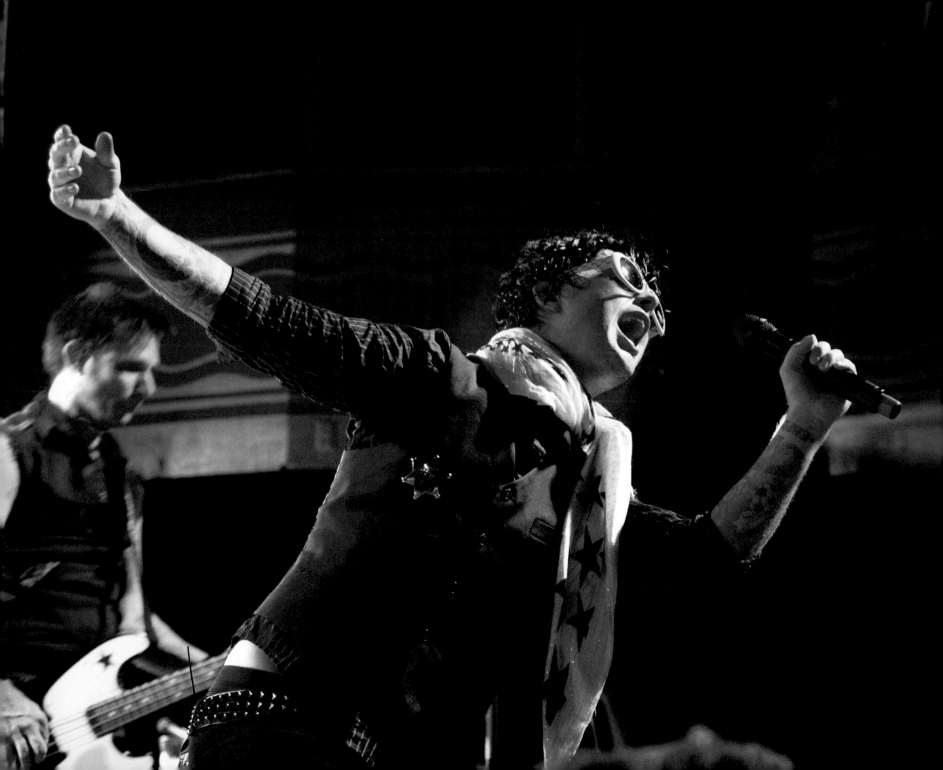

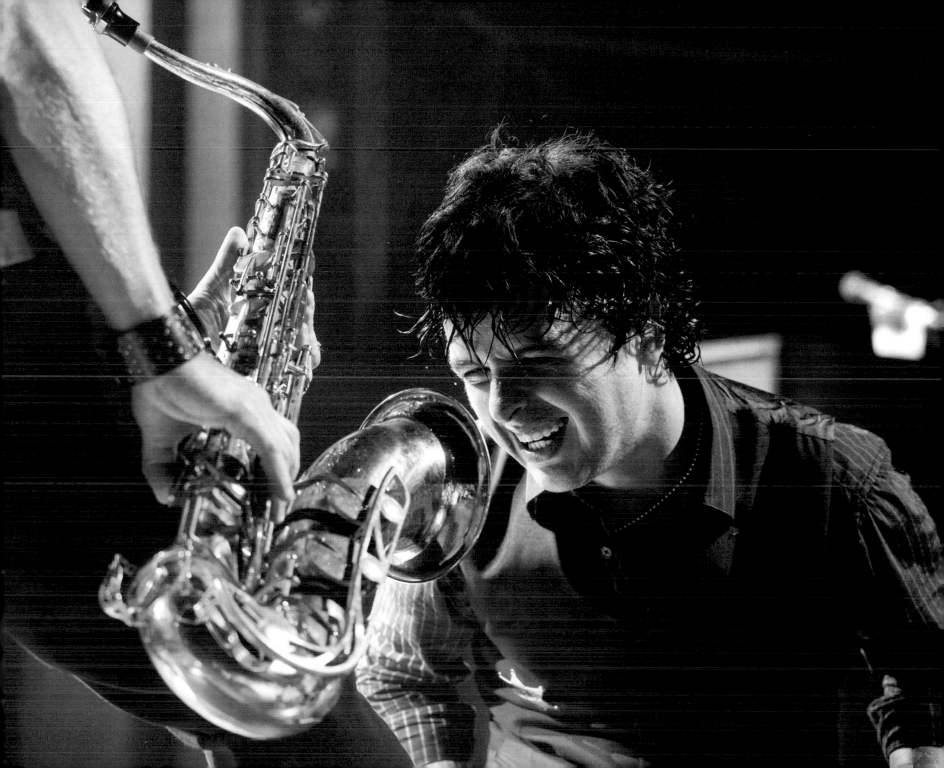

"I don't always wear eyeliner, but when I do, it's usually on my eyes..." —*Tré*

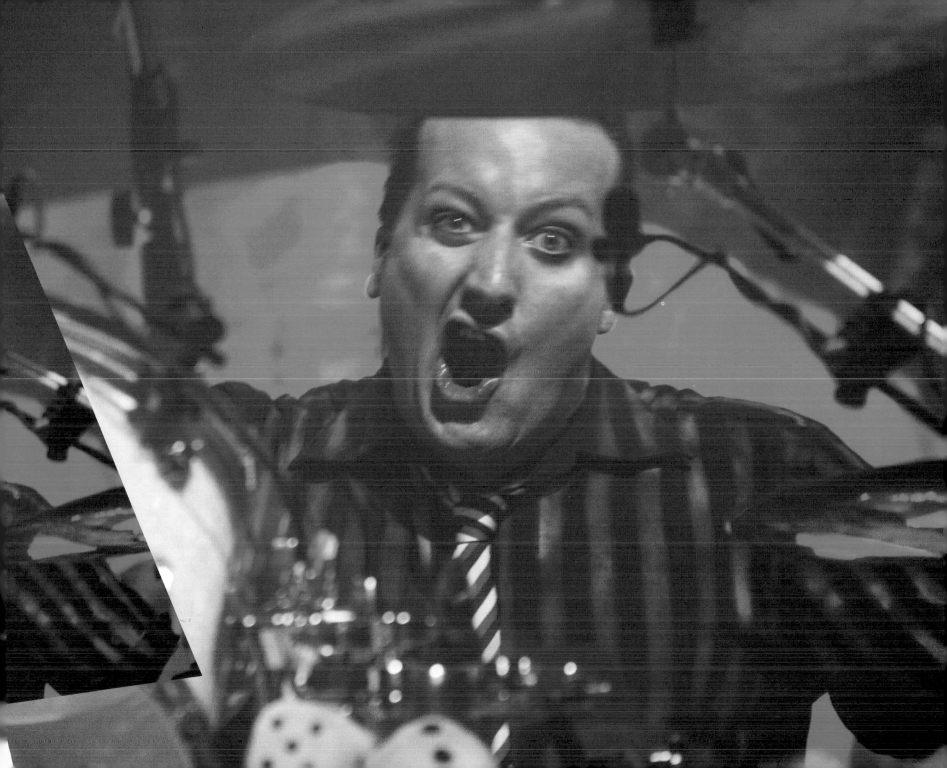

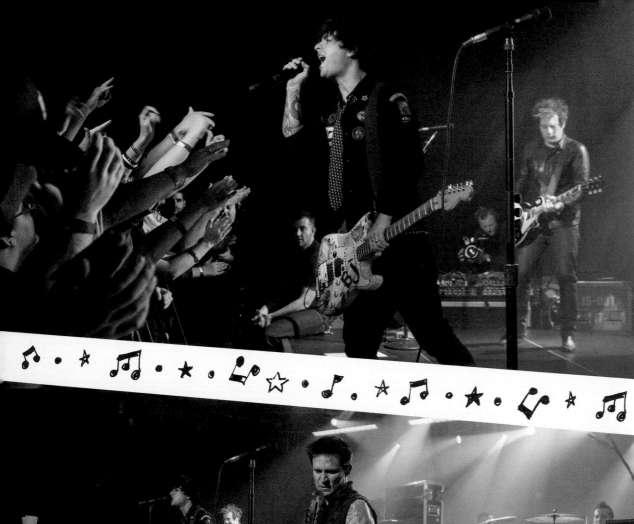

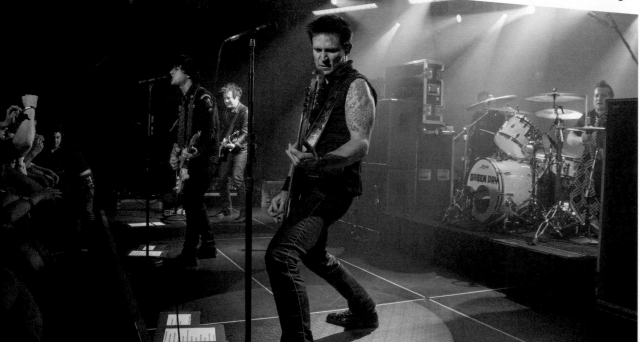

"The Colbert Report was one of the funnest TV shows we ever played."
—Green Day

PC Richard and Son Theater, NYC, May 20, 2009

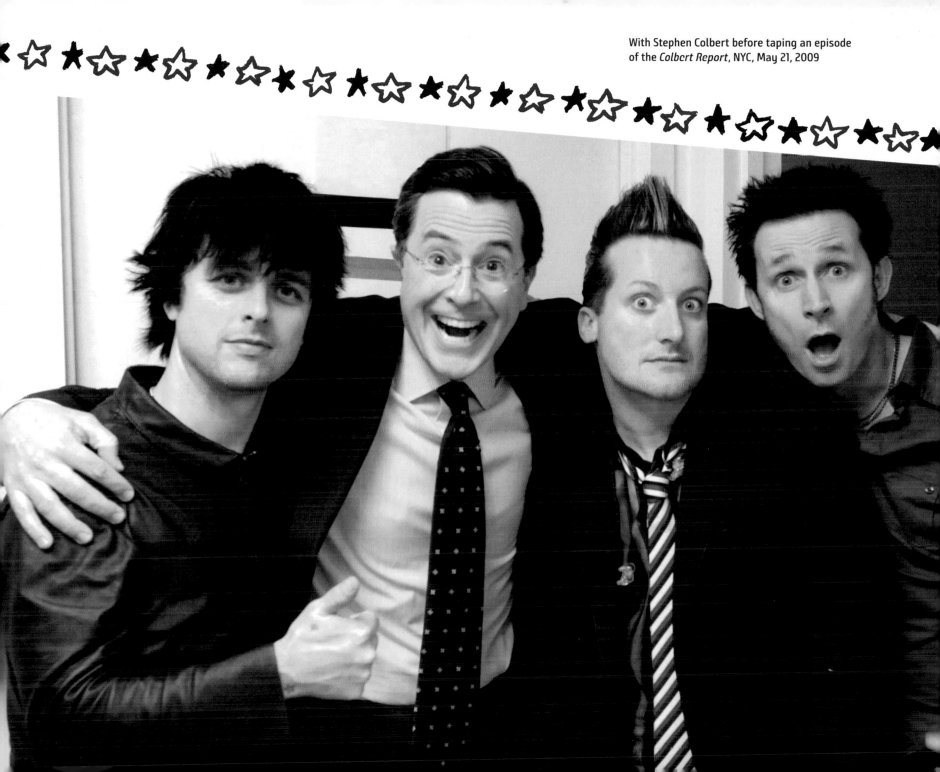

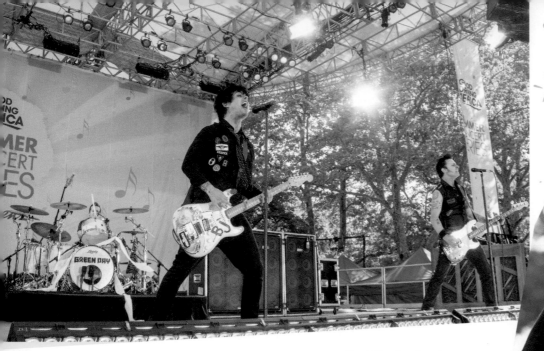

Good Morning America,
Central Park, NYC, May 22, 2009

"There's never a bad time for rock & roll, but 8 AM is pushing it...unless you stay up all night." —Mike

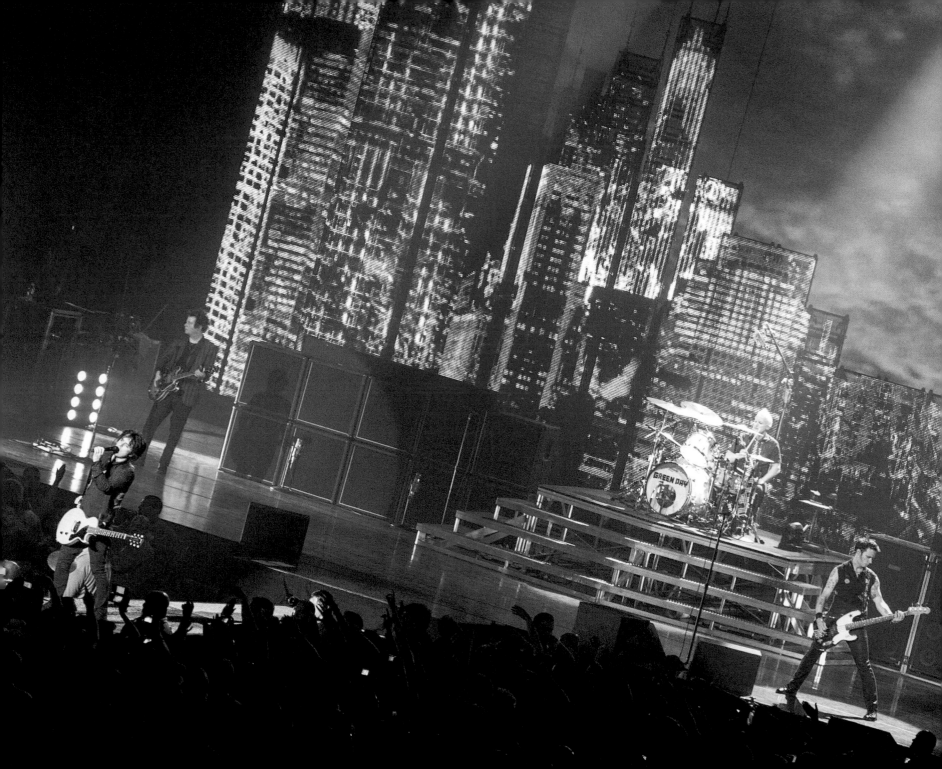

21st CENTURY BREAKDOWN WORLD TOUR

THIS SPREAD AND PAGES 68–75
Madison Square Garden,
NYC, July 27, 2009

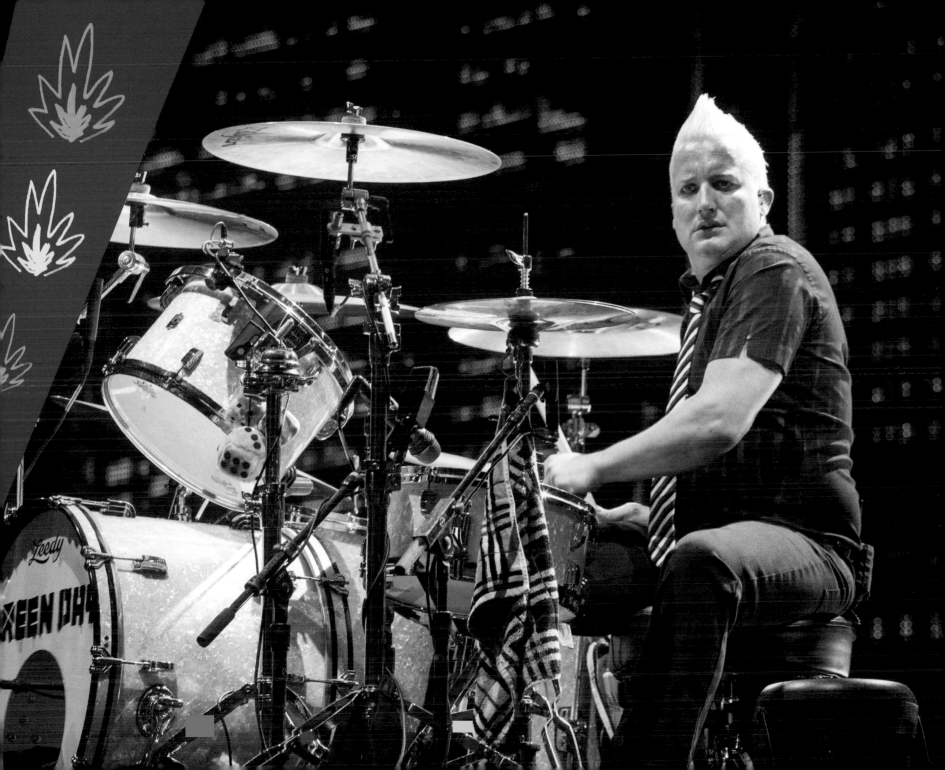

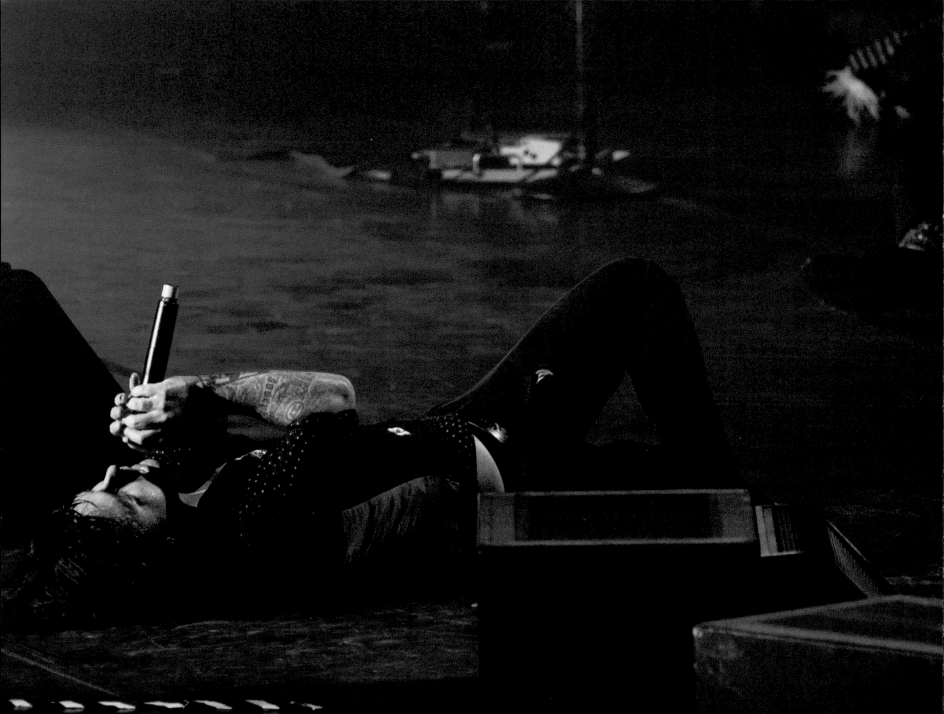

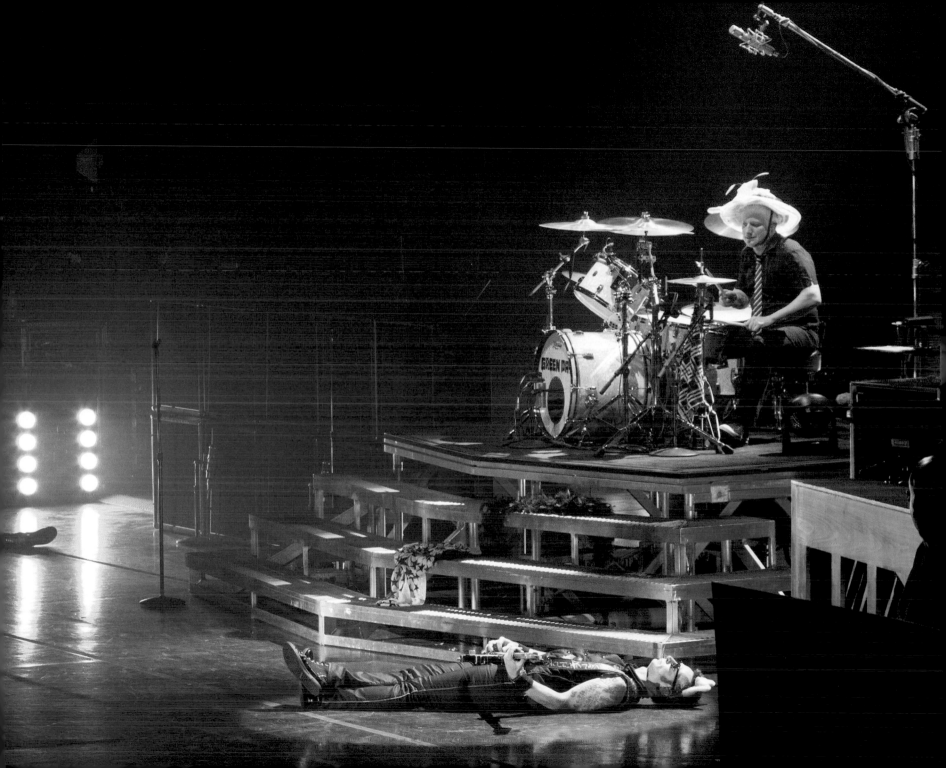

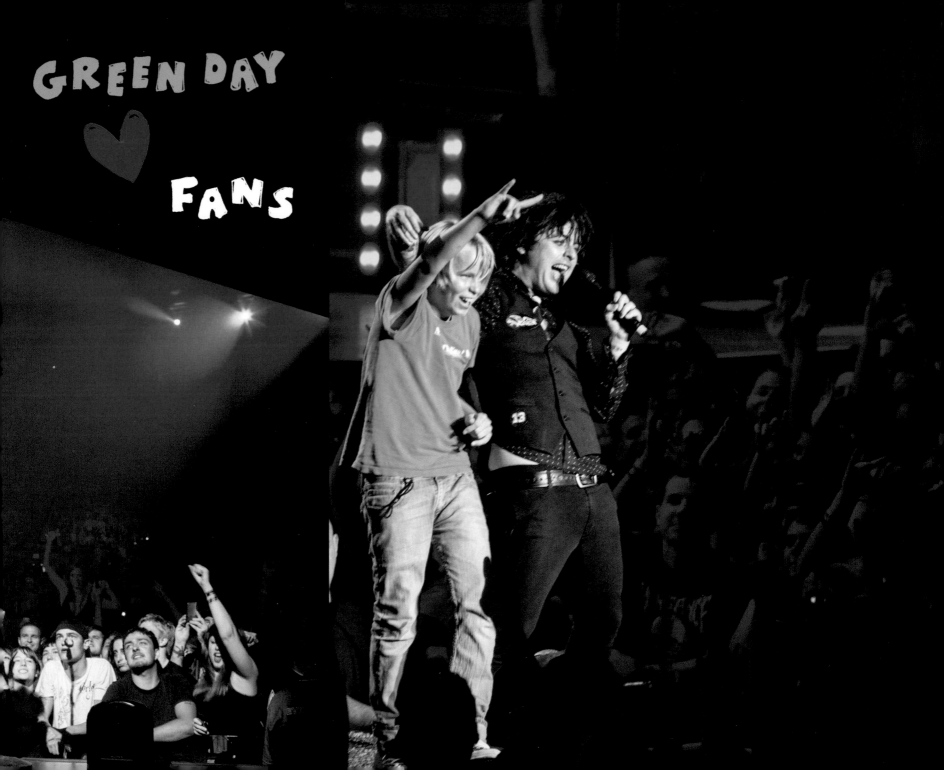

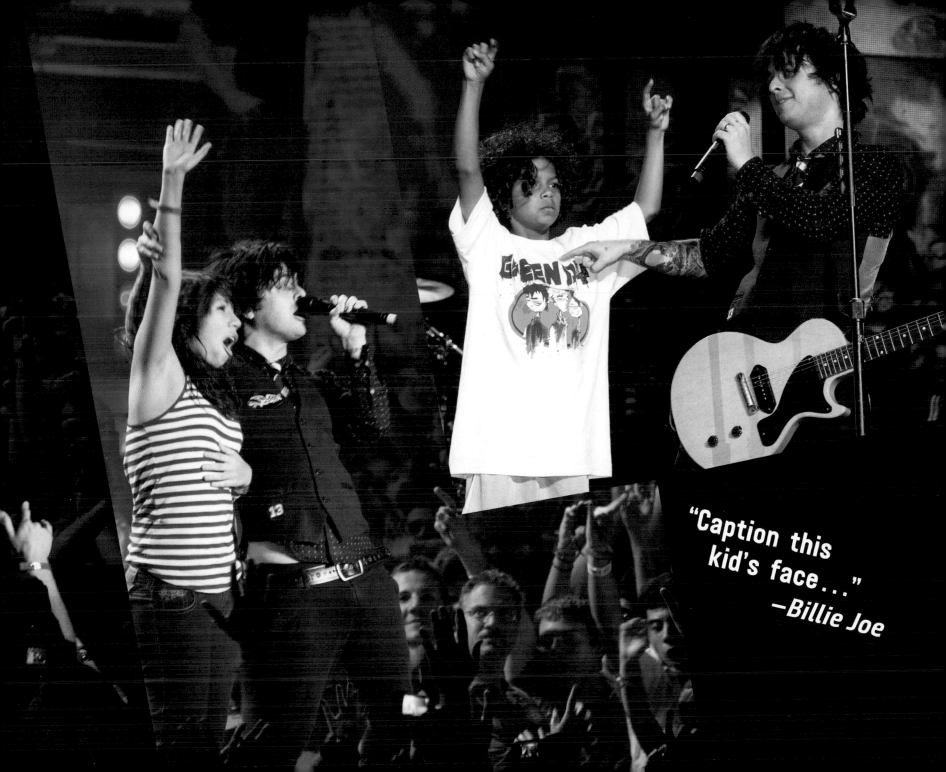

"Caption this
kid's face..."
—Billie Joe

FANS ♥ GREEN DAY

"One time we brought three kids up onstage to play bass, drums, and guitar and made them play together. I think it was in Detroit? The next time we came through town we ran into one of the kids and he told us that they ended up starting a real band together." —*Billie Joe*

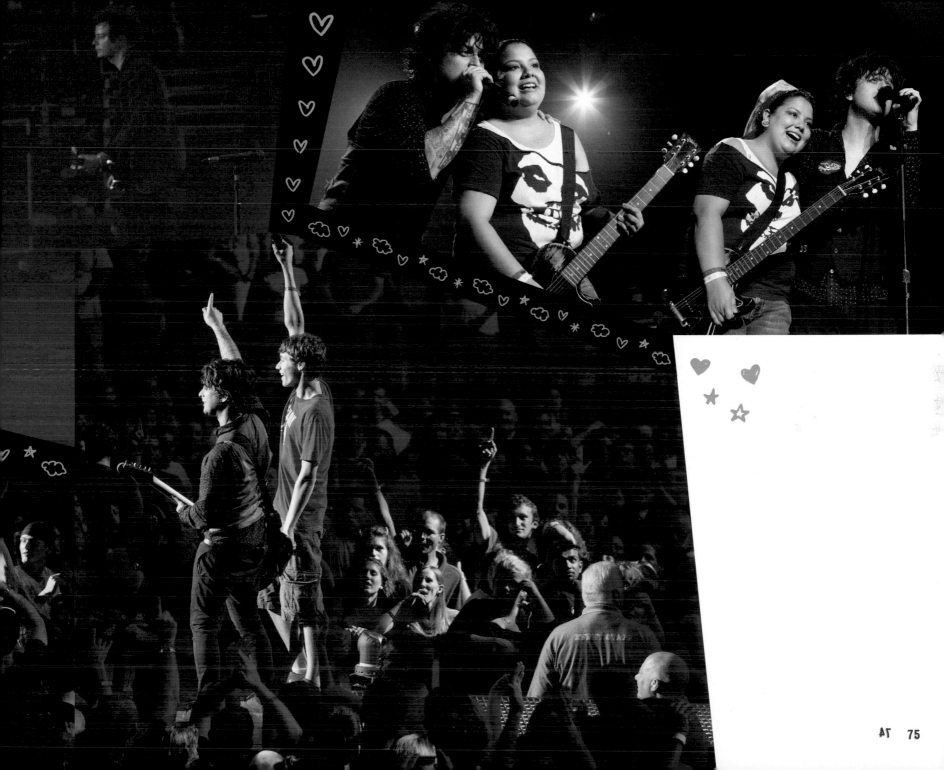

GREEN DAY
CHRISTIAN
SCIENCE
READING
ROOM

GREEN DAY
WAR
ROOM

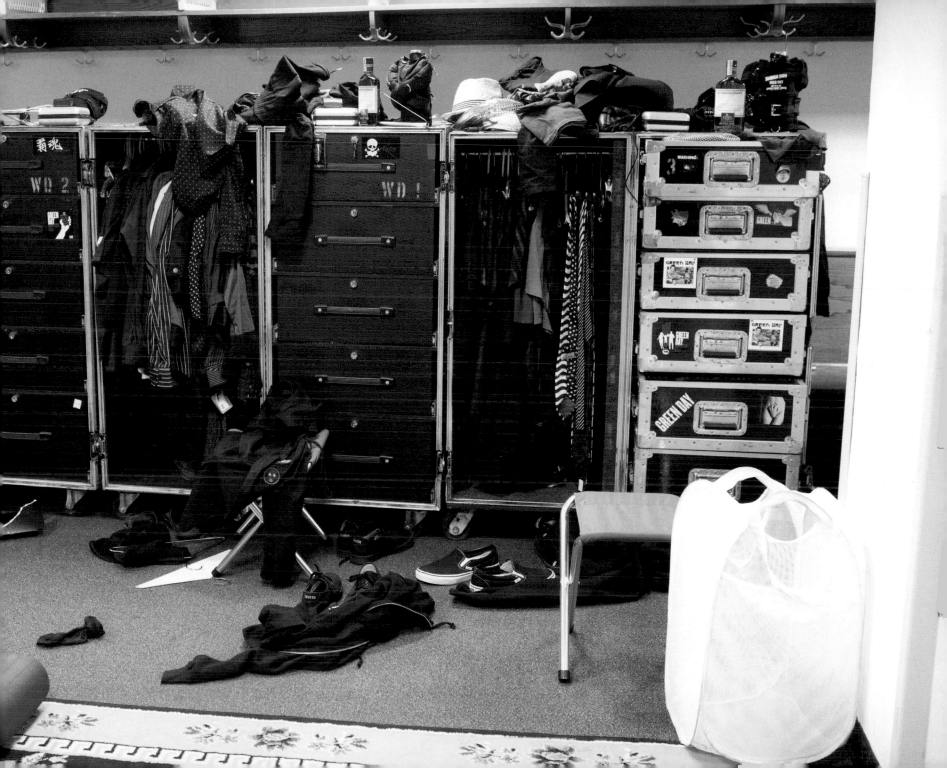

"Thirty minutes...
We got
'Blitzkrieg Bop'
...*Bunny!*
Let's walk!"
—*Tré*

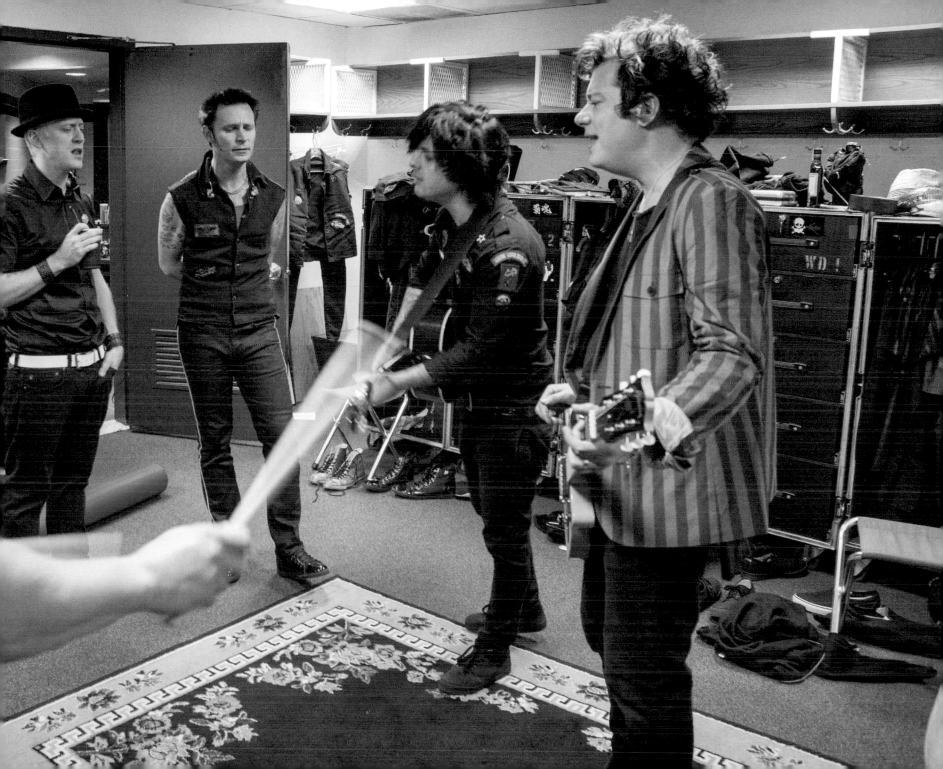

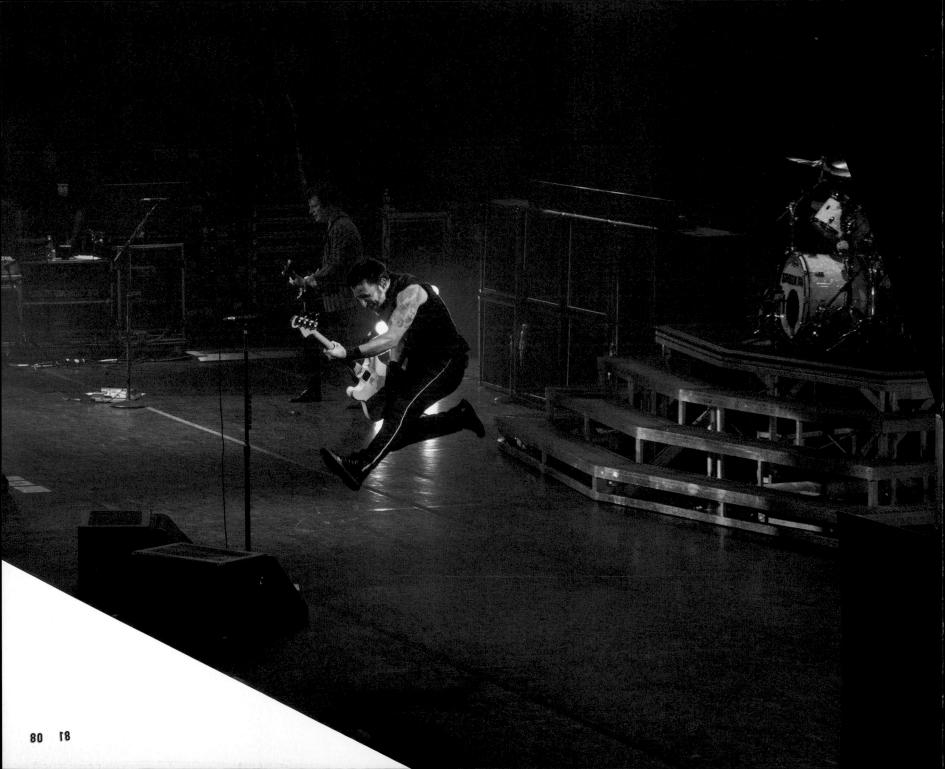

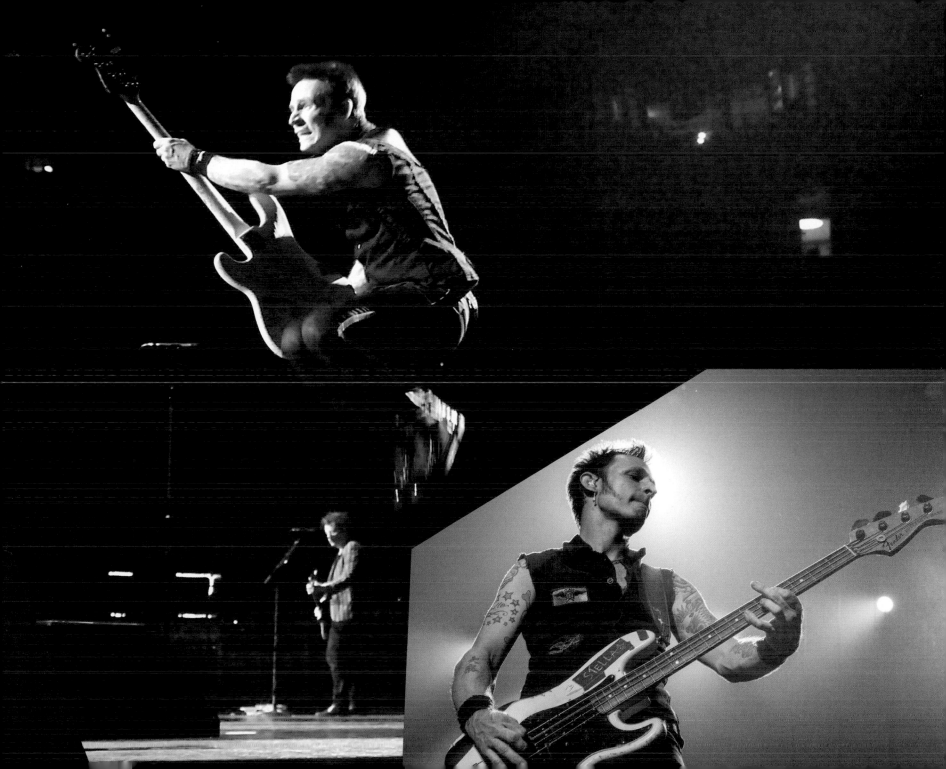

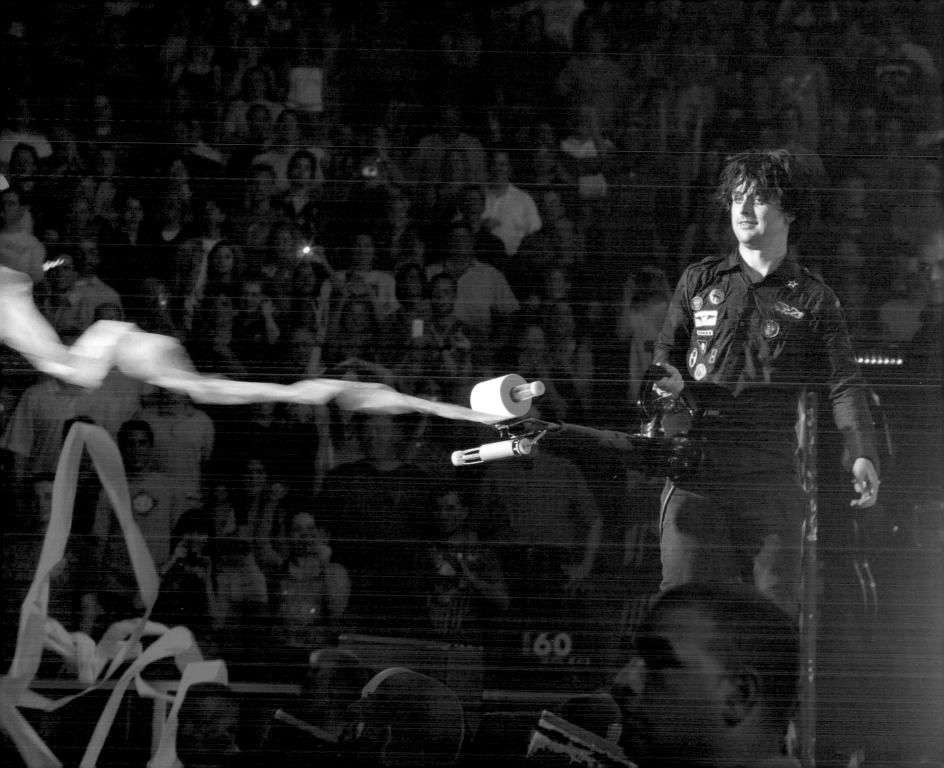

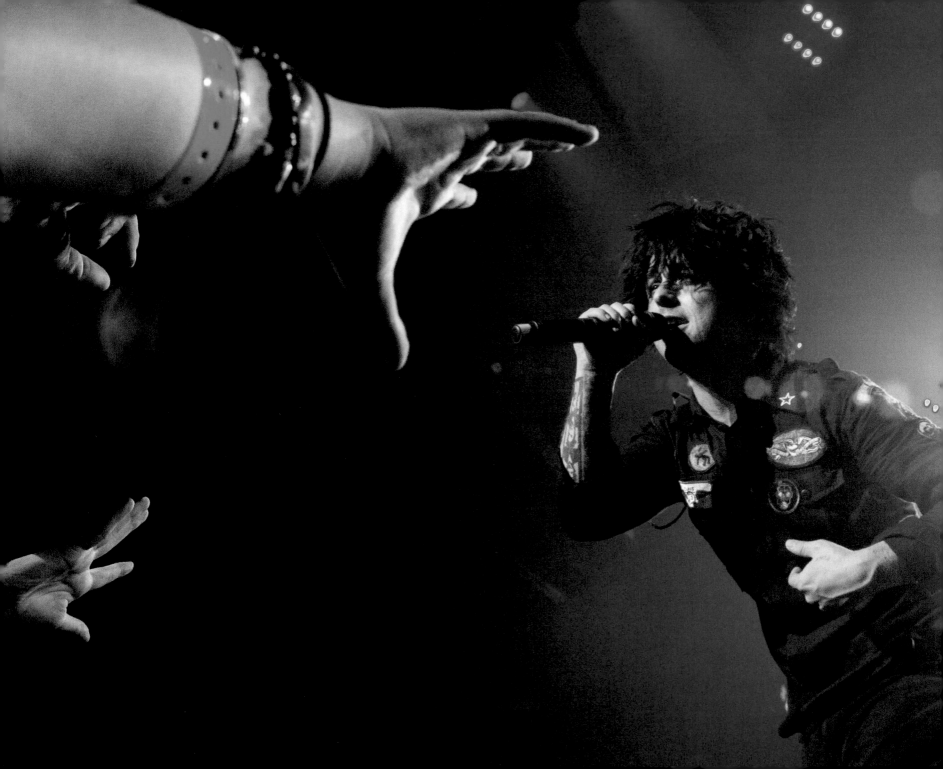

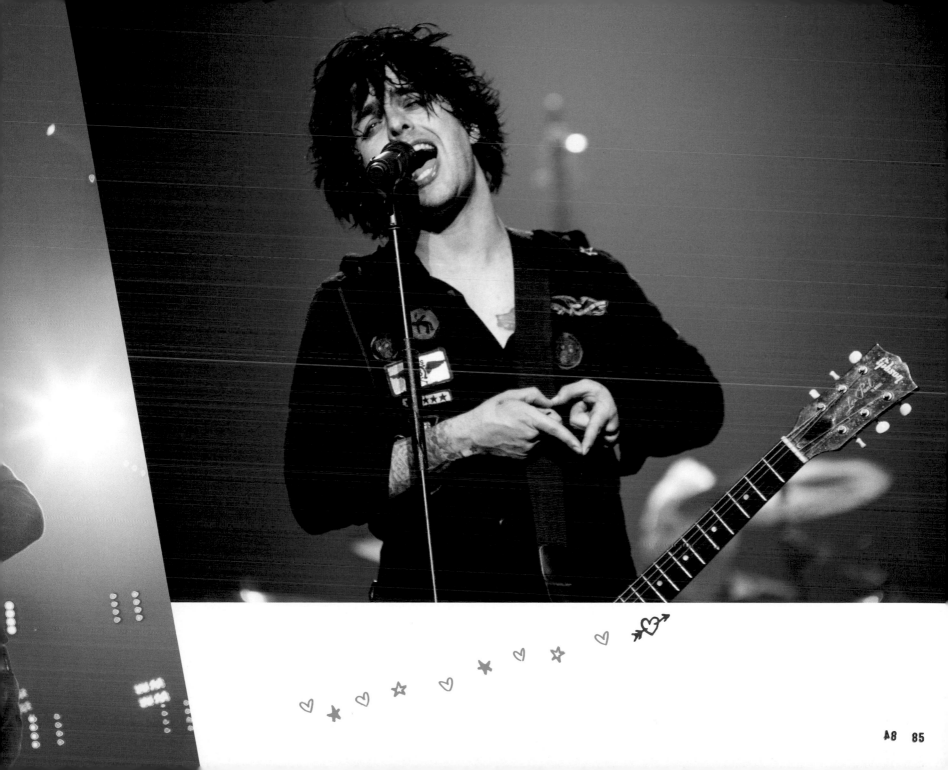

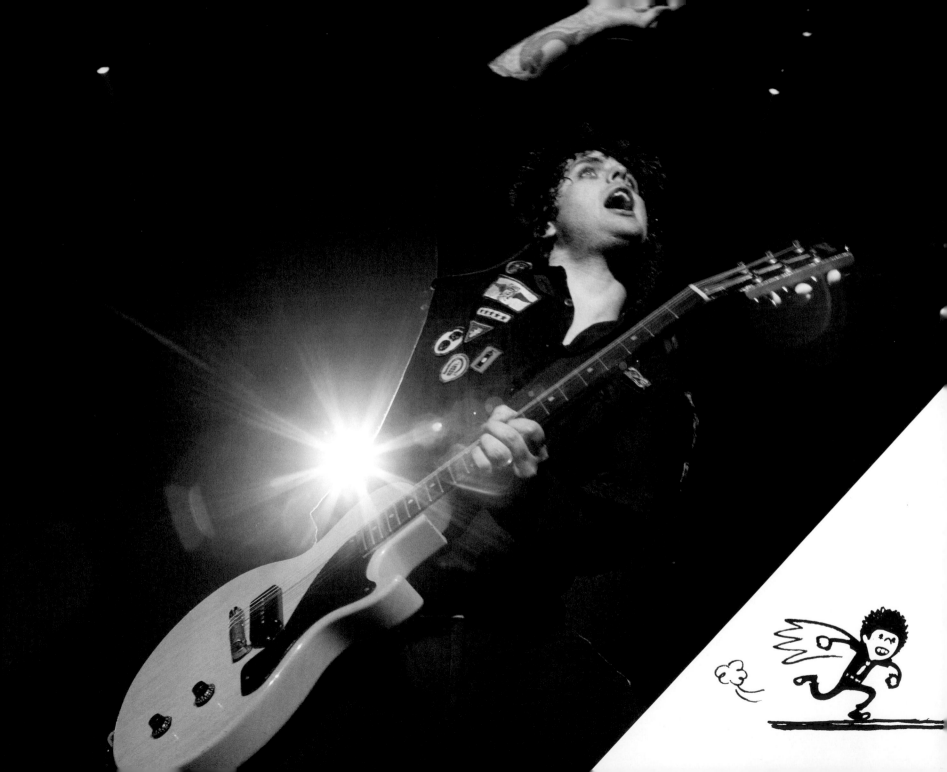

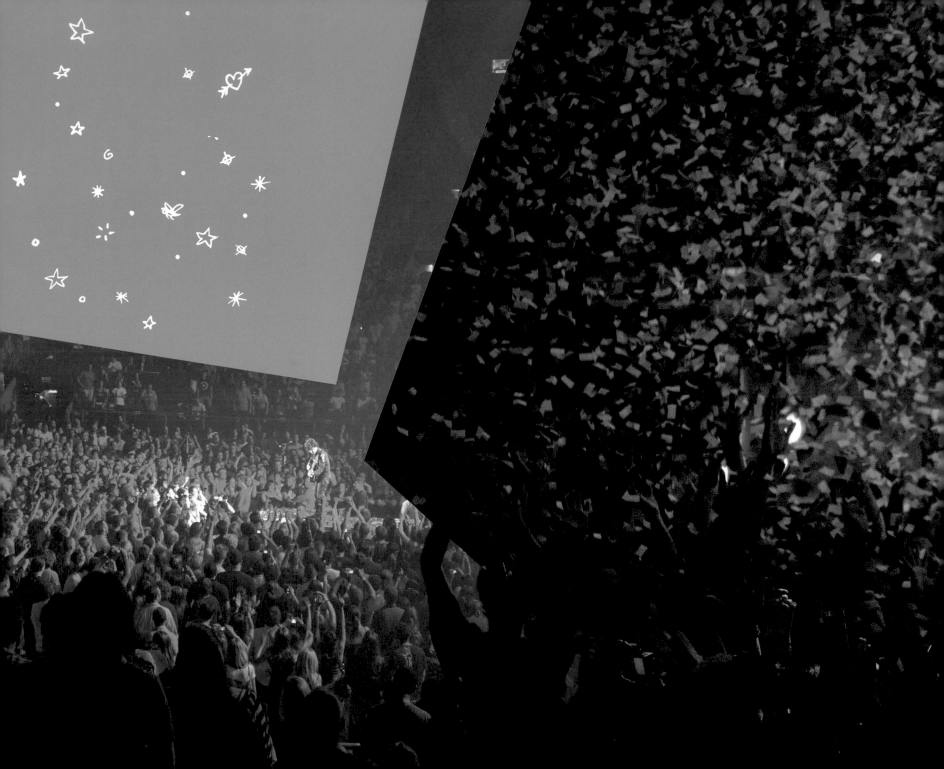

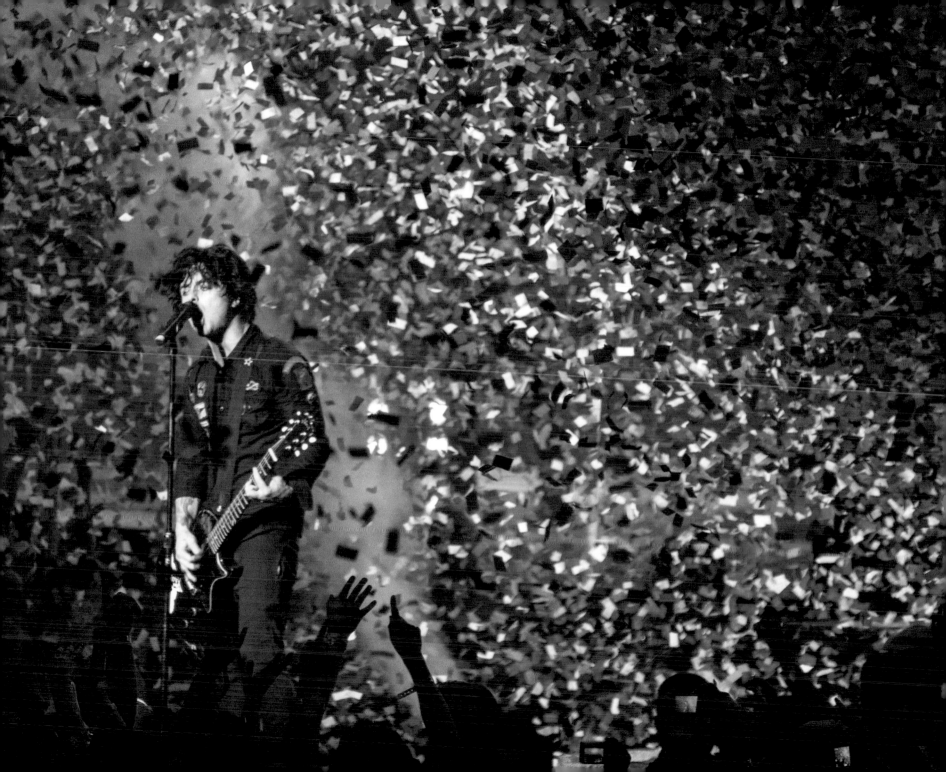

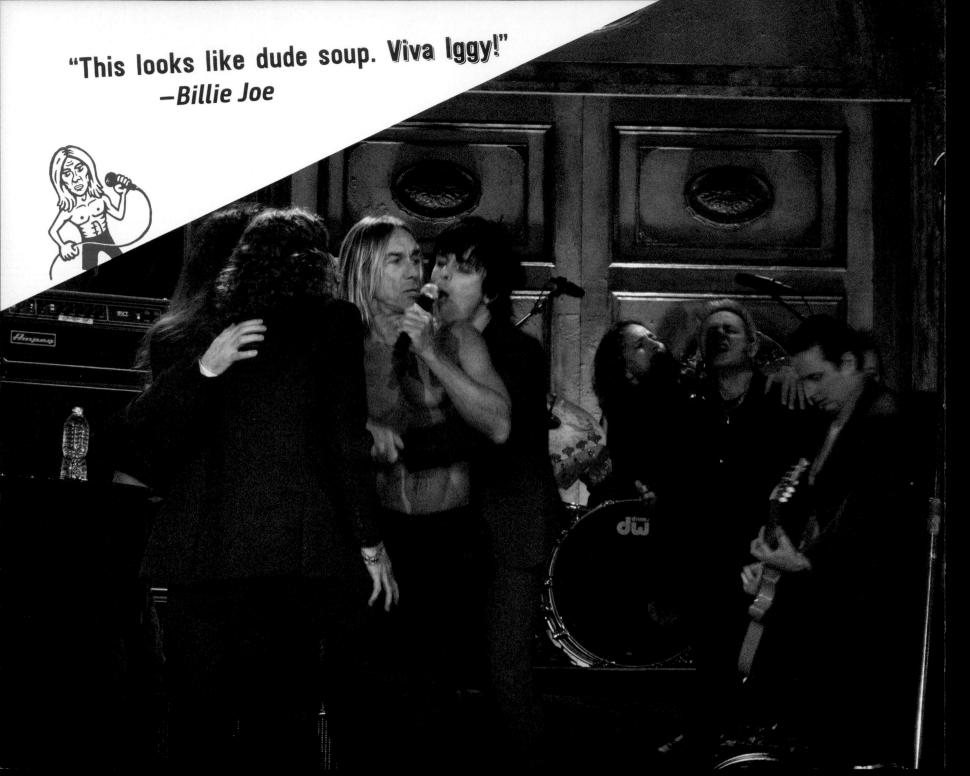

"This looks like dude soup. Viva Iggy!"
—Billie Joe

Foxboro Hot Tubs

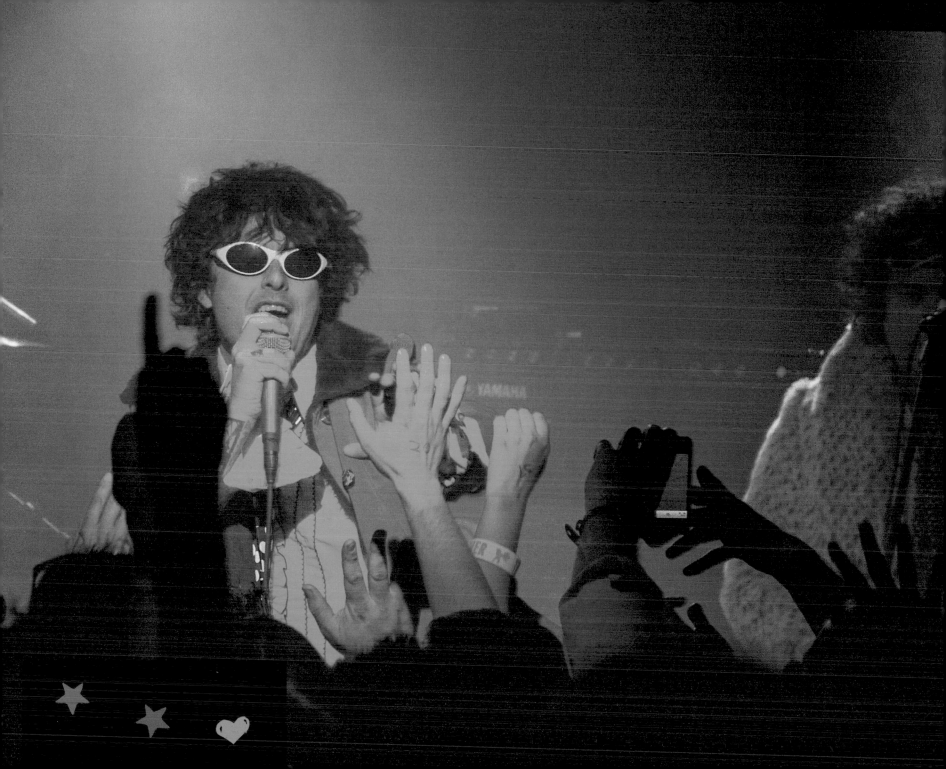

"Bill Murray was spotted at this show!"
—Mike

PAGES 92–101
Foxboro Hot Tubs, Don Hill's,
NYC, April 23, 2010

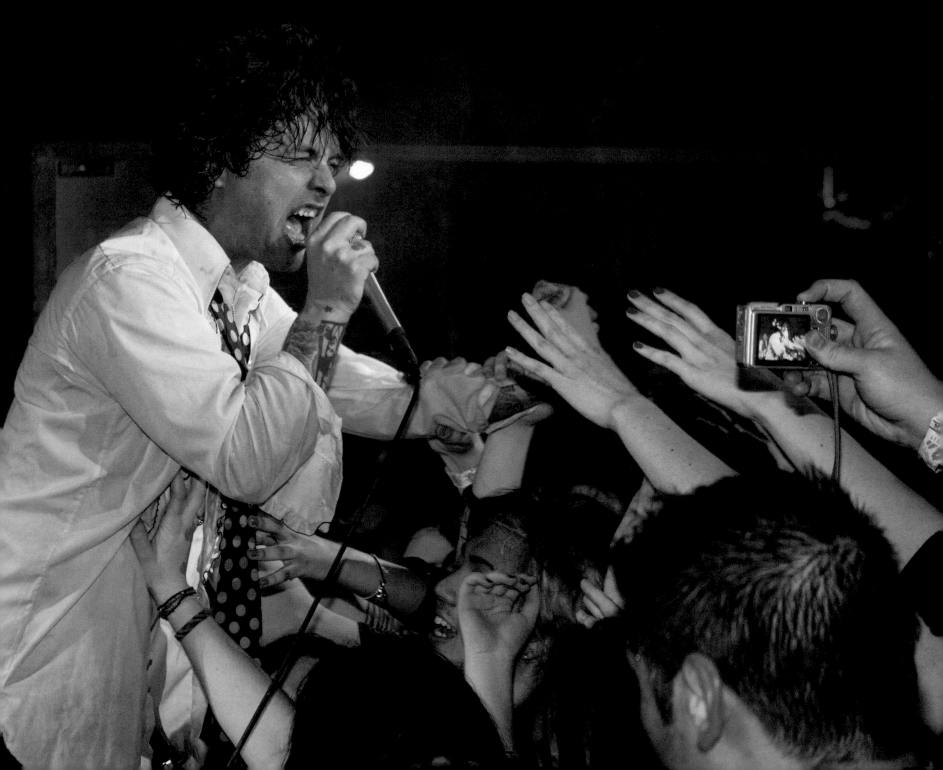

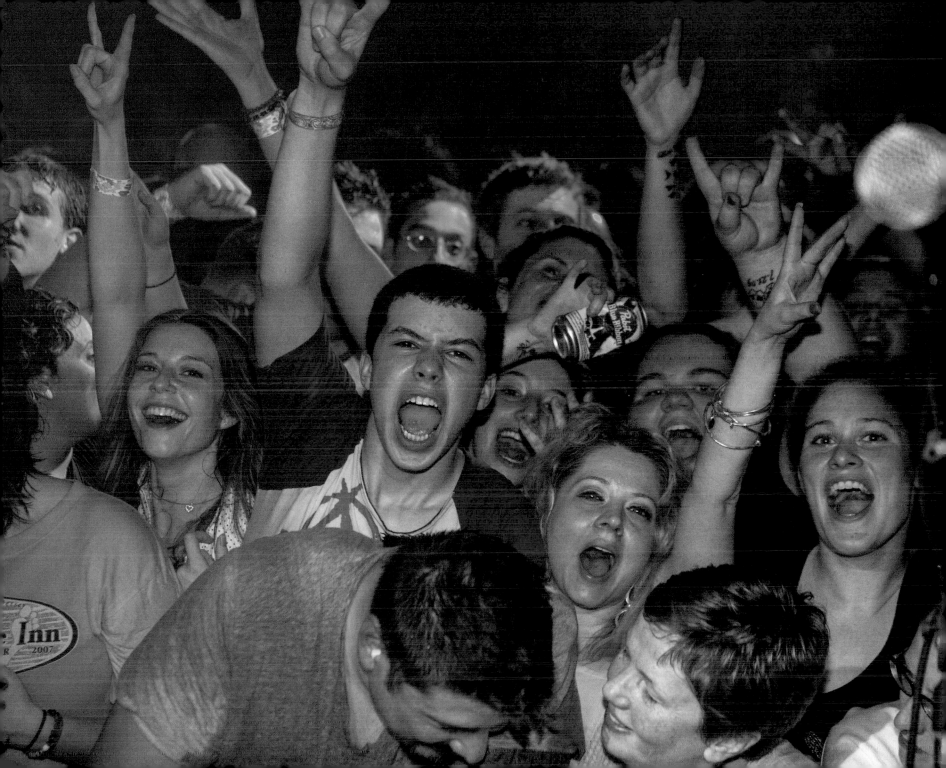

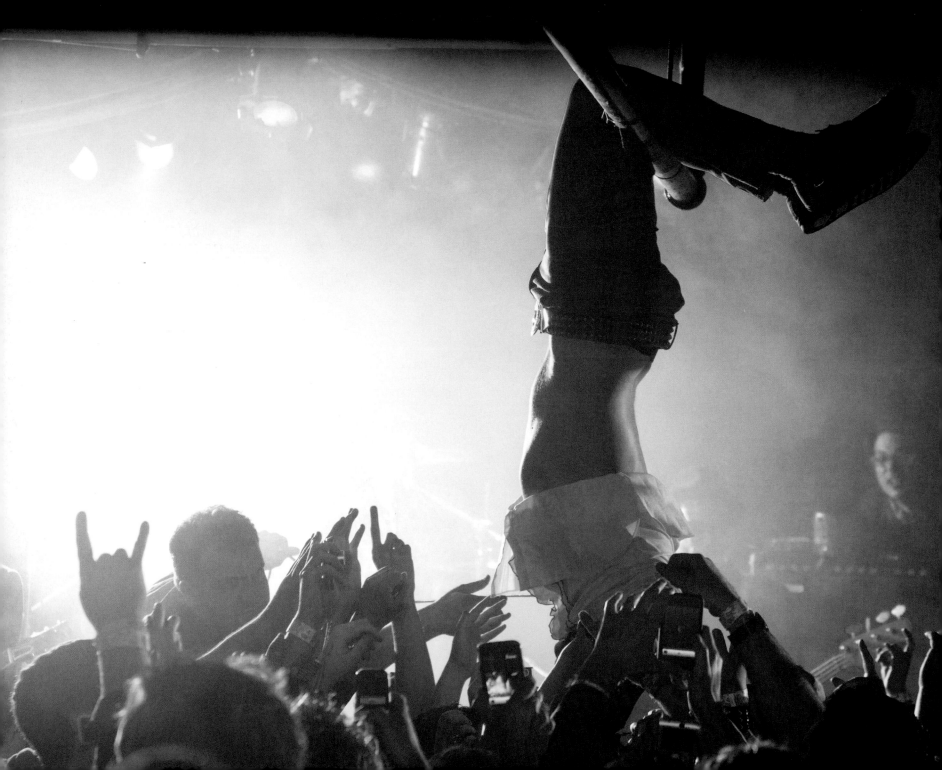

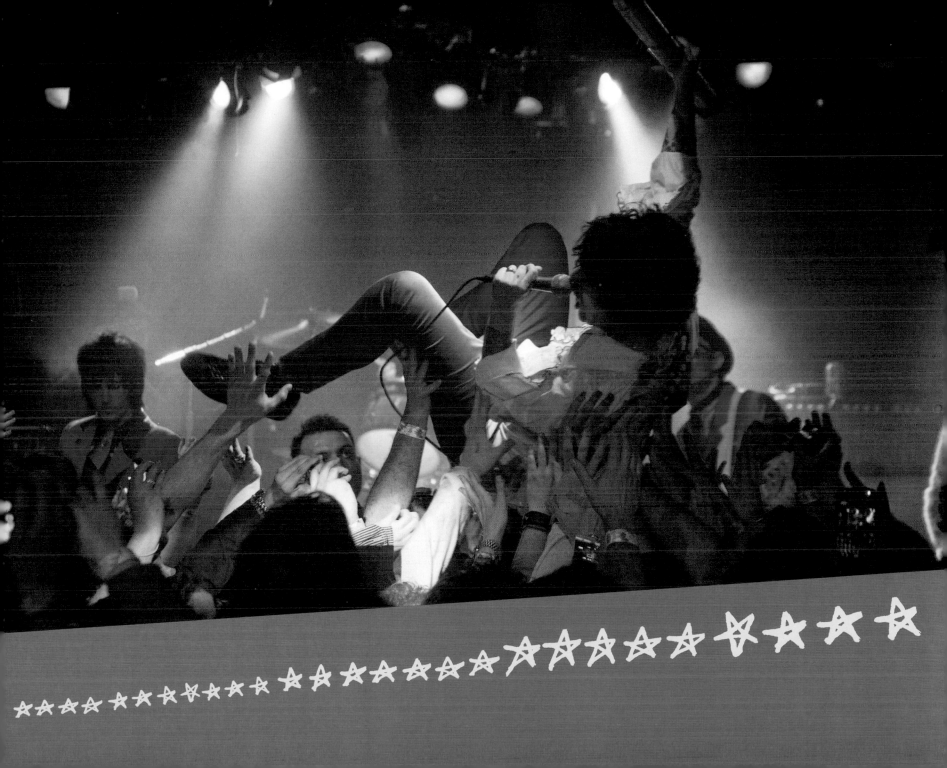

"Hot Tubs shows are my favorite gigs ever... Blood, broken teeth, beer, and urine." —*Billie Joe*

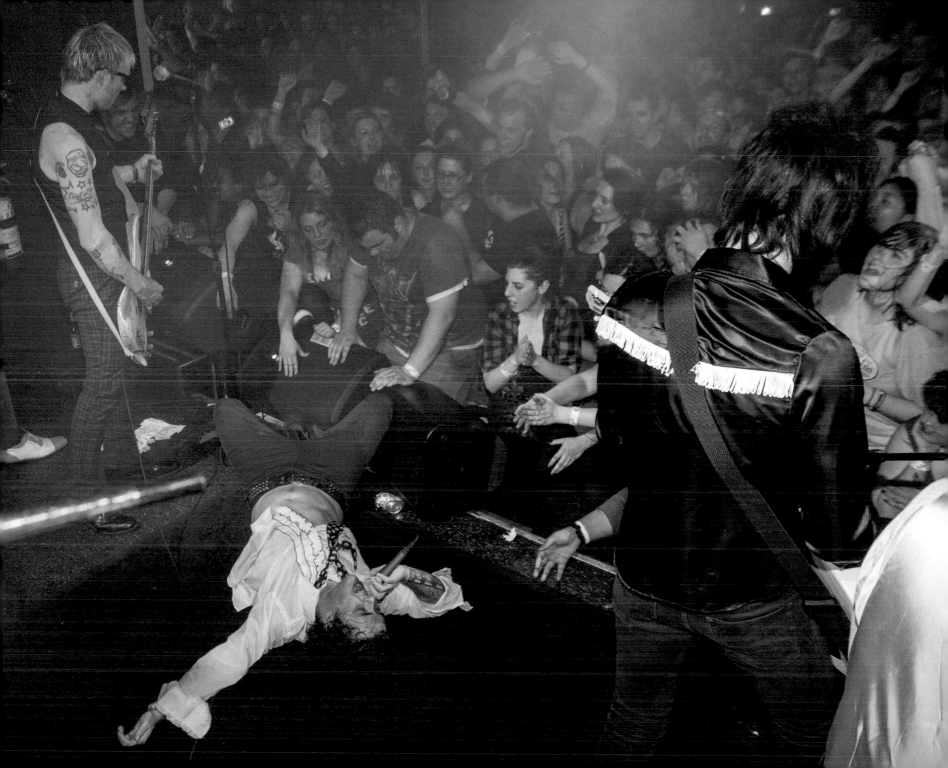

"Told you that bass was heavy." —Mike

THIS SPREAD AND PAGES 104–07
Foxboro Hot Tubs, Bowery Electric, NYC, April 25, 2010

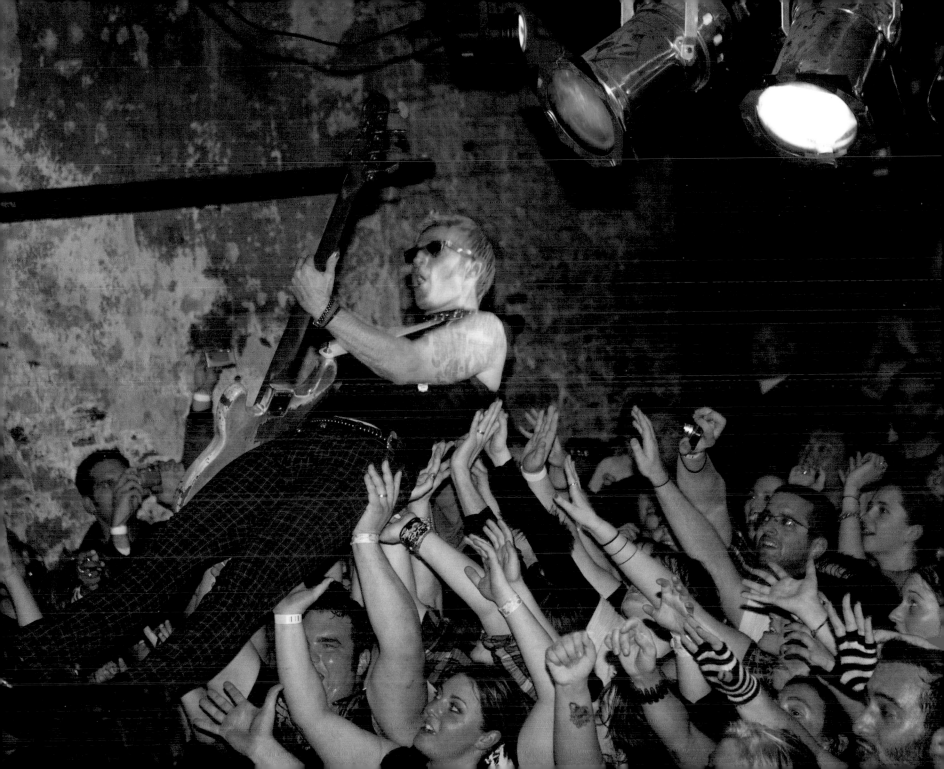

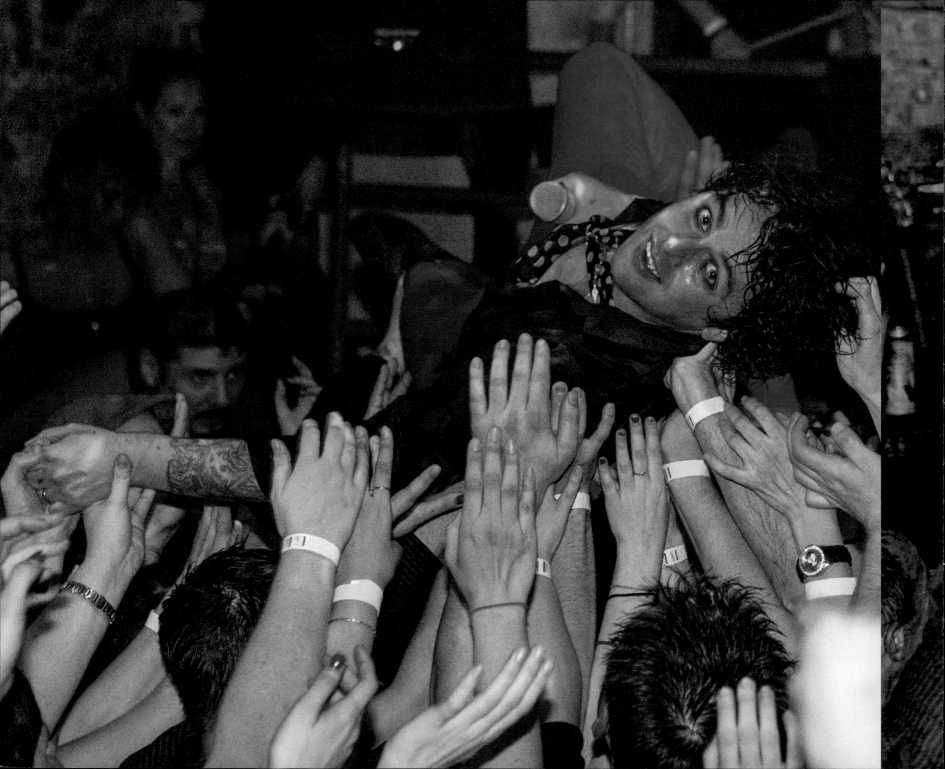

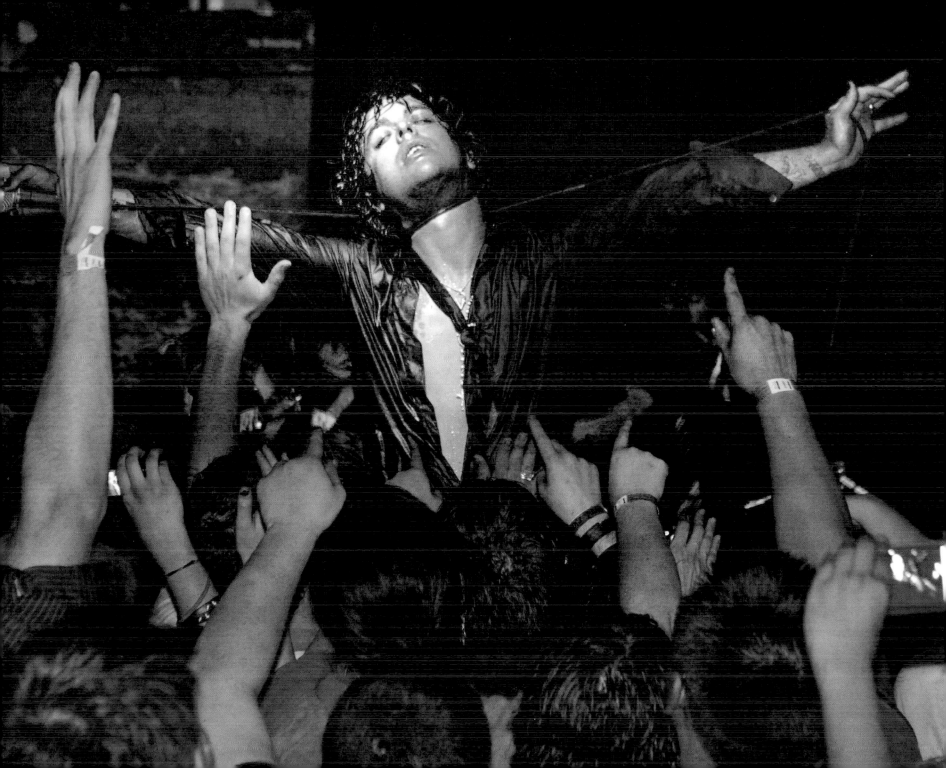

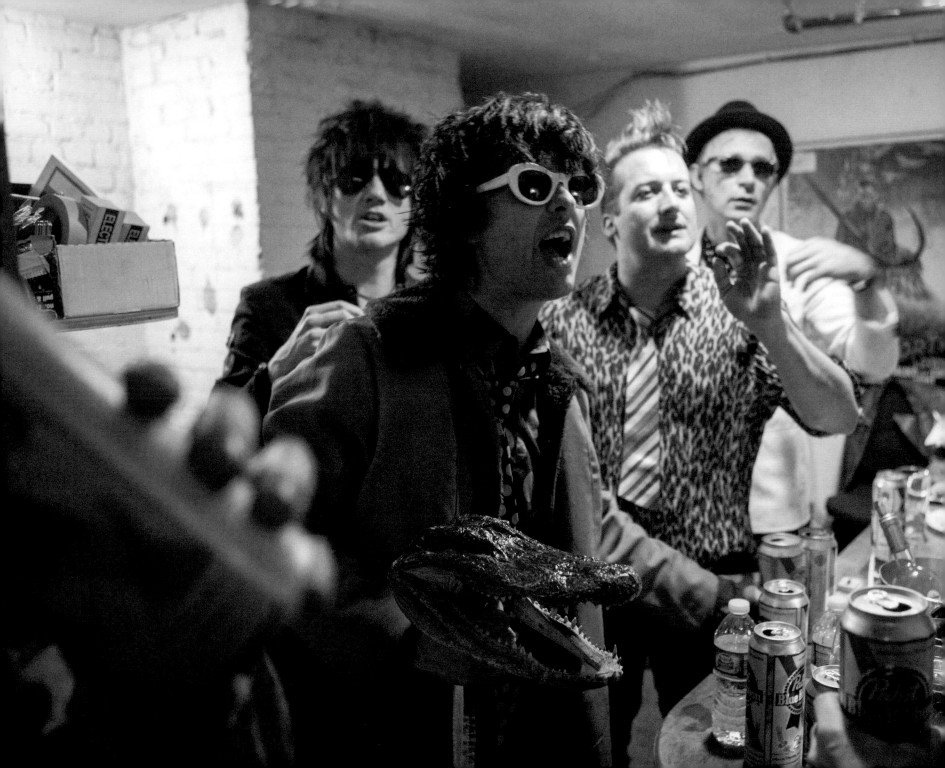

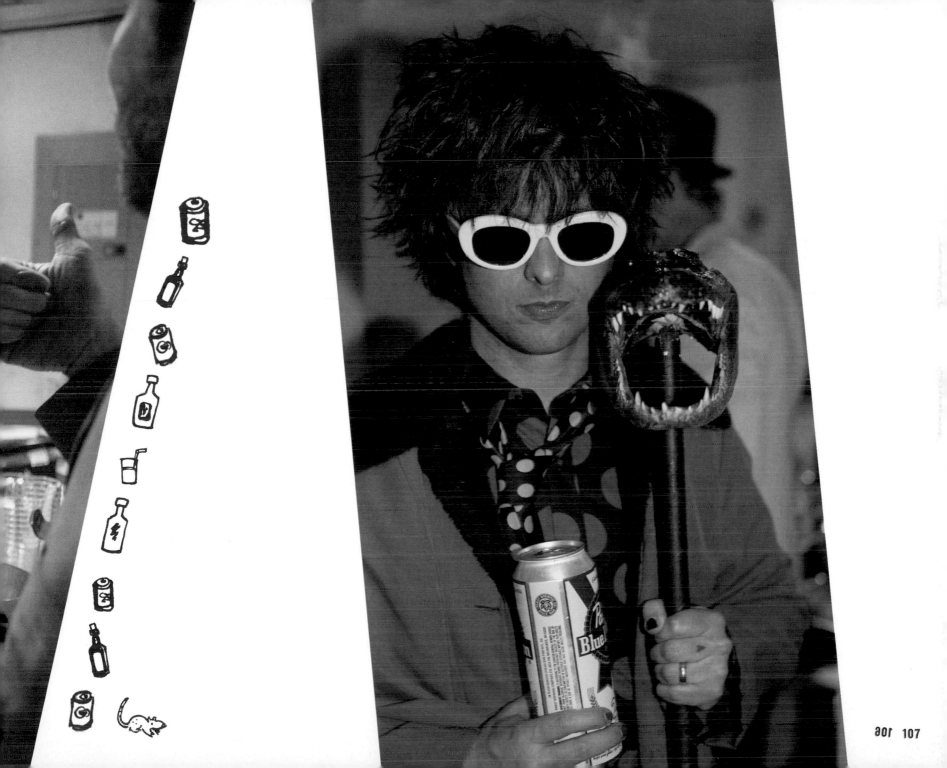

"True love between perfect weirdos."
—Mike

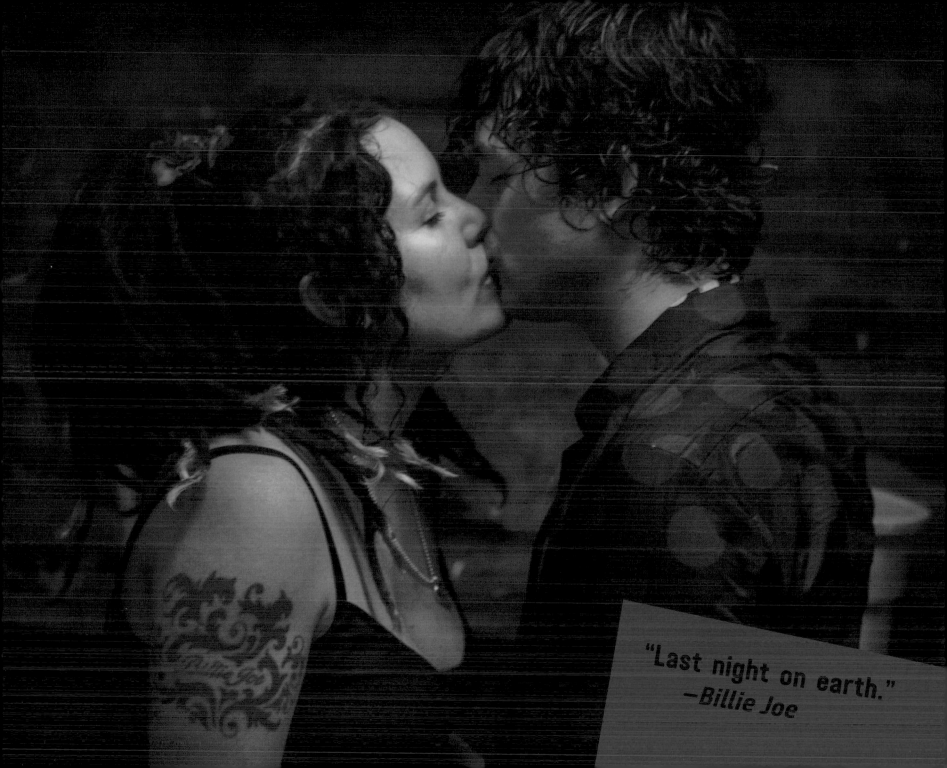

"Last night on earth."
 —Billie Joe

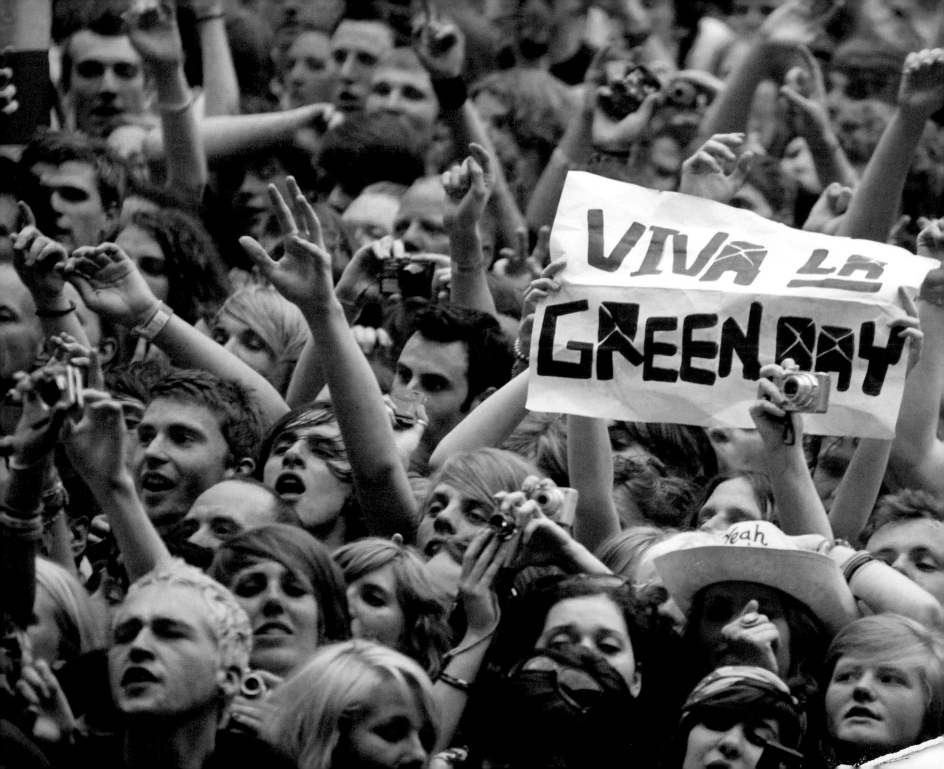

GREEN DAY WORLD TOUR

"Billie Joe told me that Joan Jett would be opening some of their shows in Europe. I told him I would love to see that, so he talked to his manager and arranged to bring me over as their guest."
—Bob

THIS SPREAD AND PAGES 112–13
Wembley Stadium, London, June 19, 2010

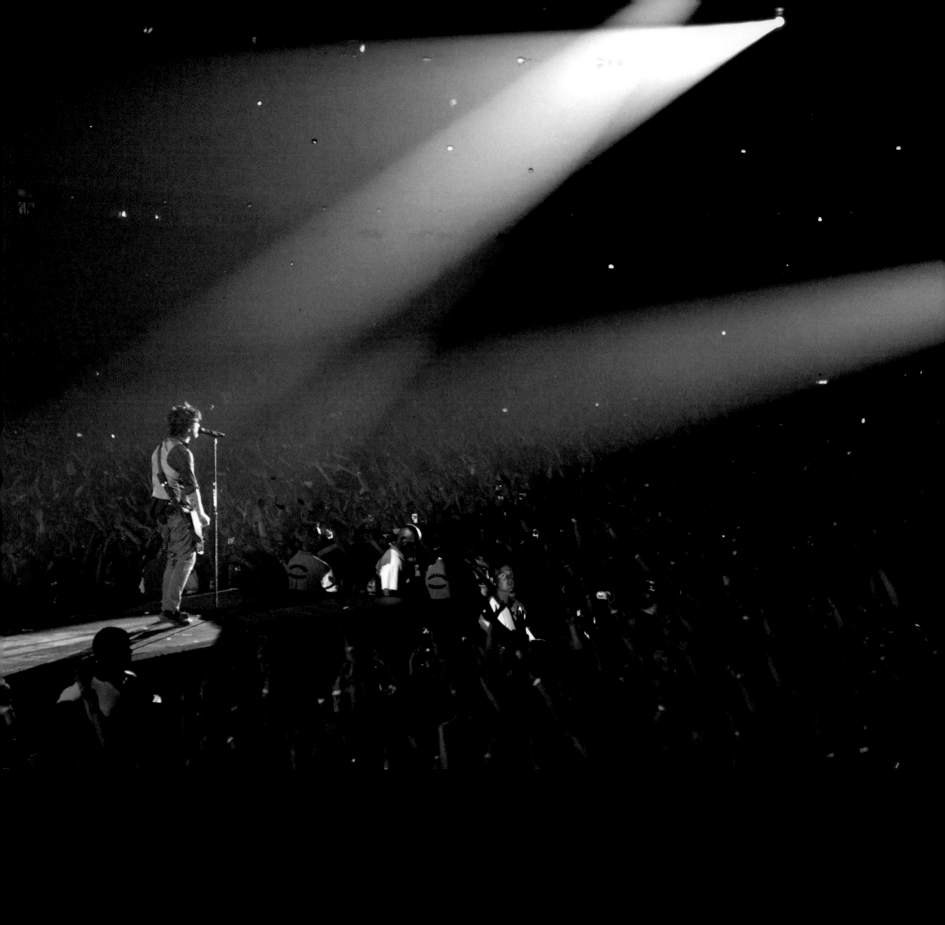

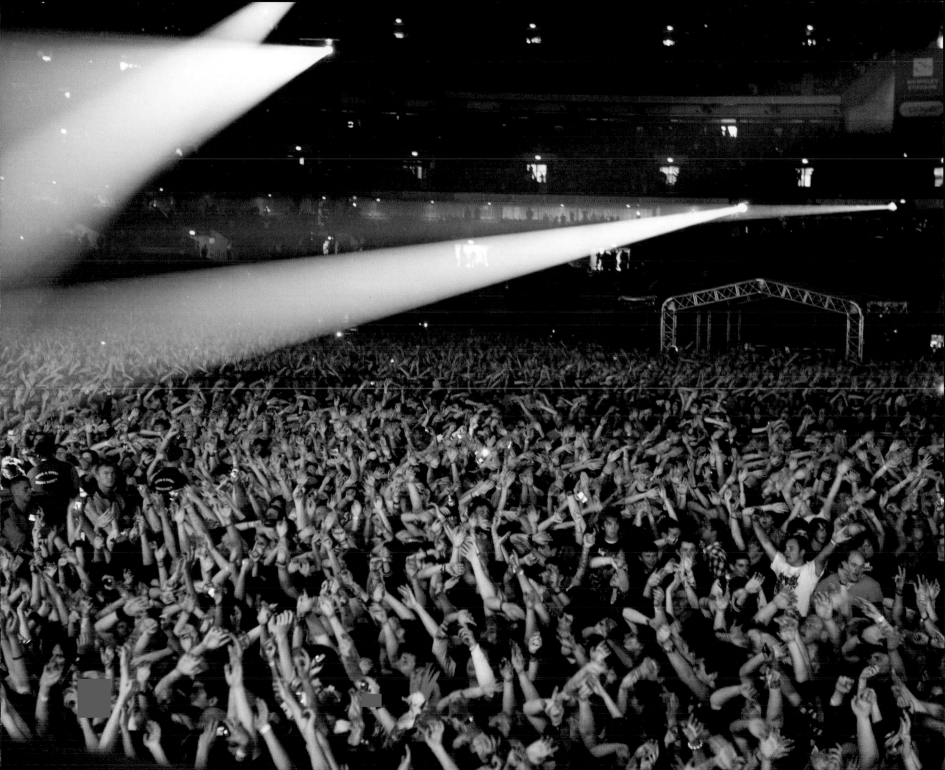

"Two of the most powerful, inspirational women in the world...and three guys." —Green Day

"We had such a great tour with Green Day throughout Europe, and the pinnacle was Wembley Stadium, where this picture was taken." —Joan Jett

"Serena Williams told the band that she was twelve the first time she saw them, when her father took her and her sister Venus to see their show in Florida." —Bob

ABOVE Billie Joe Armstrong, Serena Williams, Joan Jett, Tré Cool, and Mike Dirnt, Wembley Stadium, London, June 19, 2010

RIGHT AND PAGES 116–19 Wembley Stadium, London, June 19, 2010

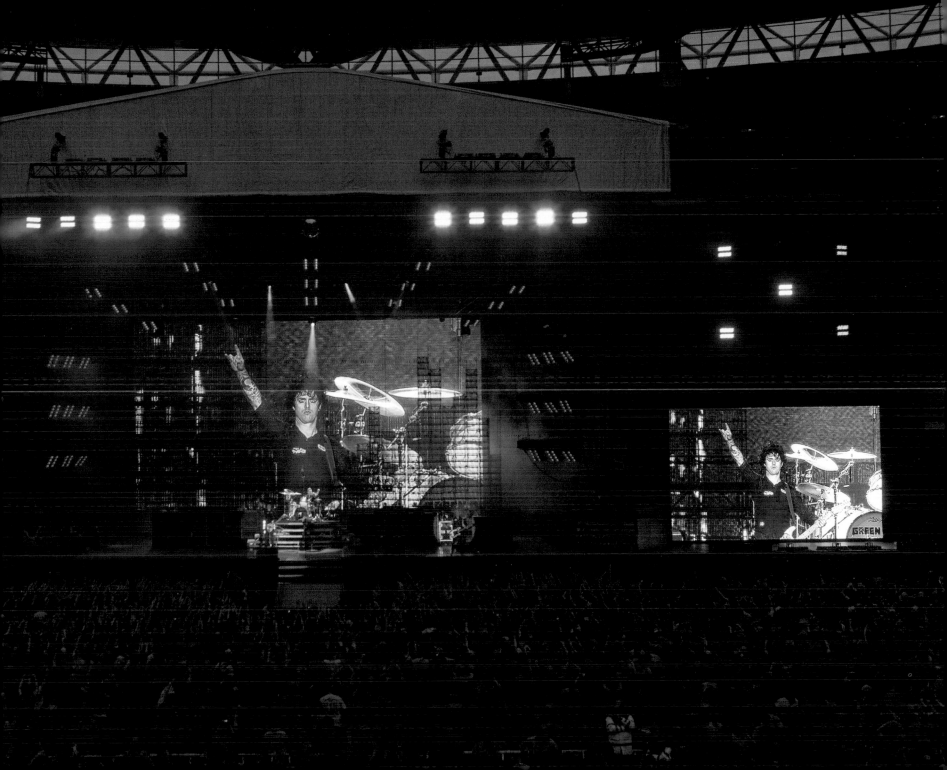

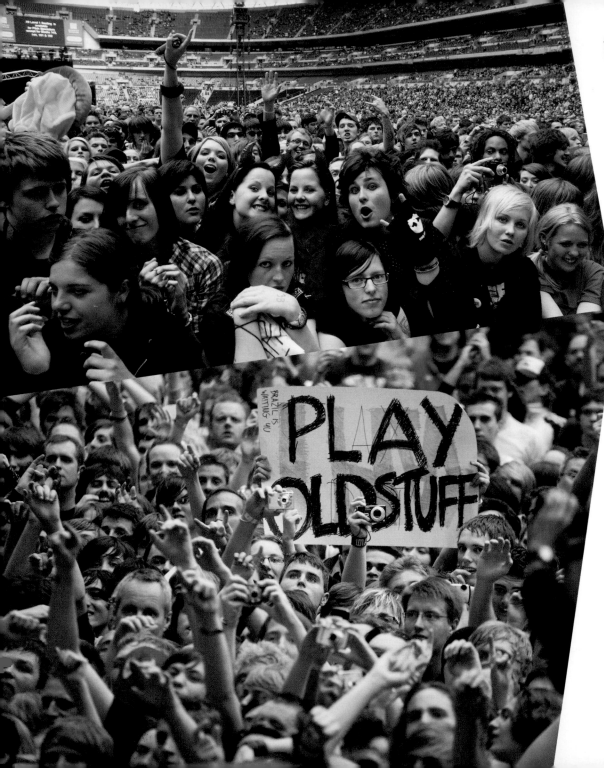

"The Wembley Stadium show was our biggest at the time, with over 90,000 people."
—Billie Joe

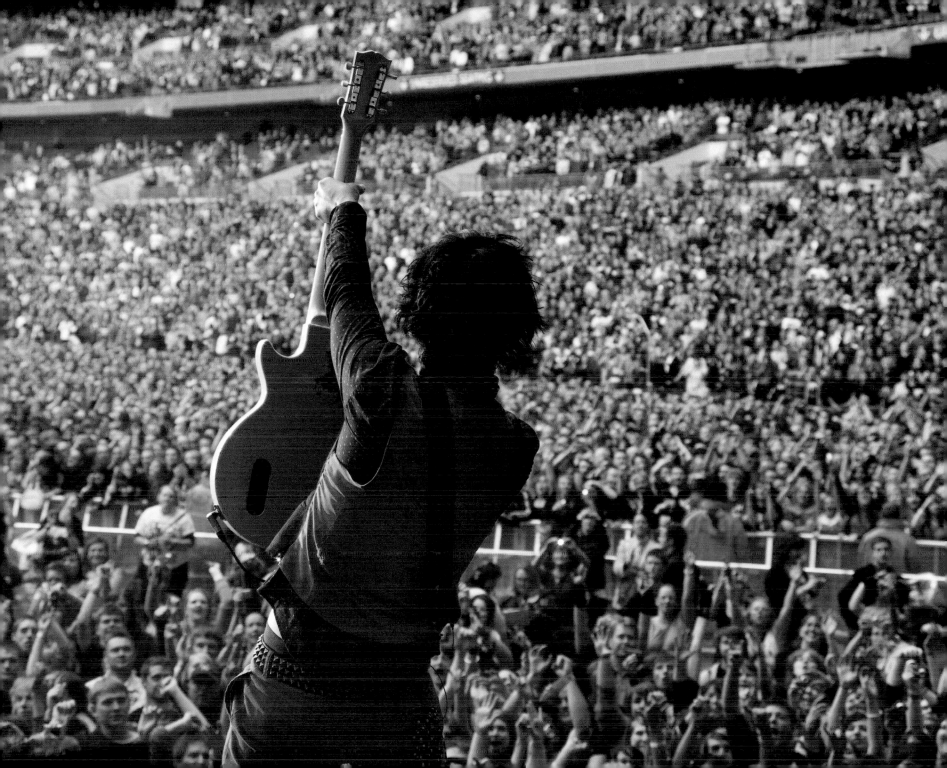

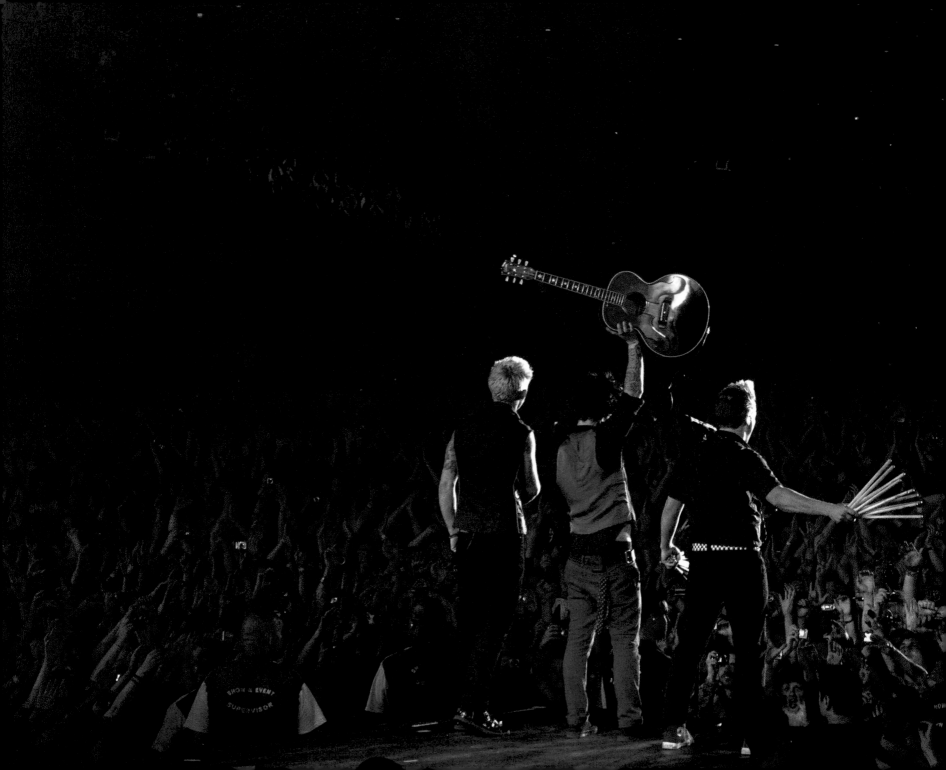

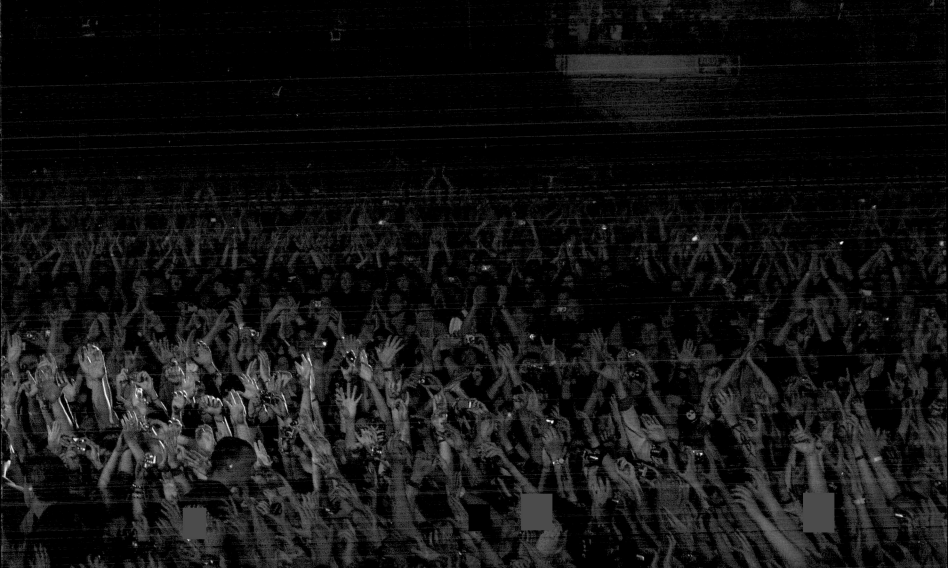

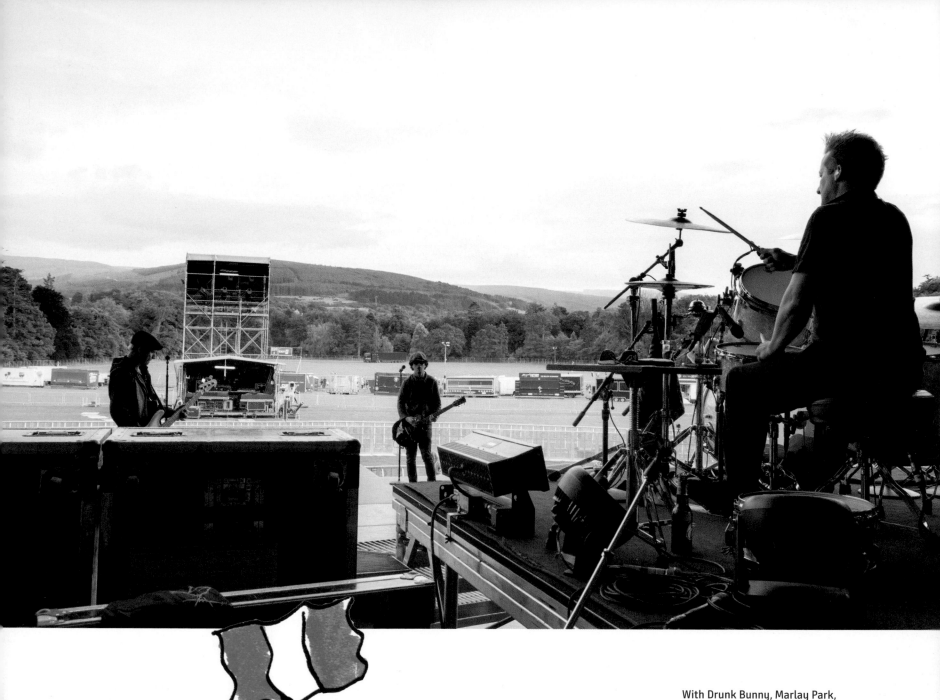

With Drunk Bunny, Marlay Park,
Dublin, Ireland, June 23, 2010

"Beer has always calmed the nerves…for the bunny, that is…"
—Billie Joe

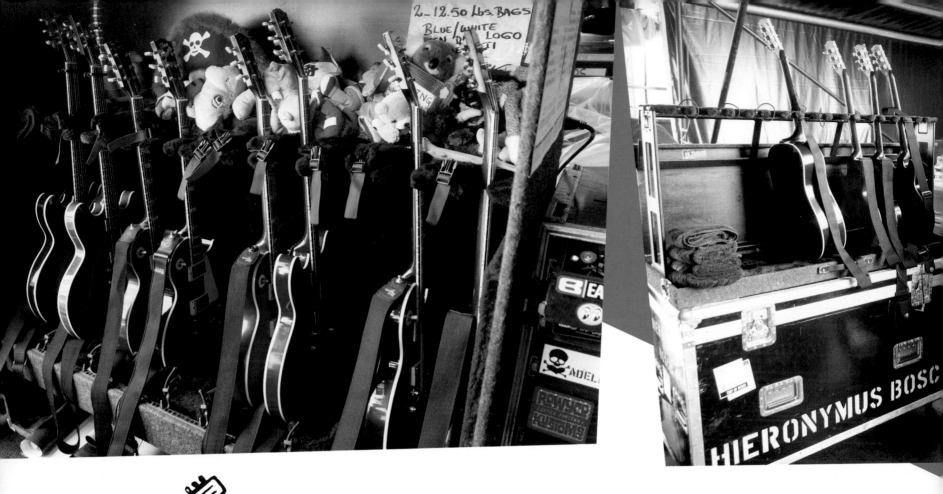

2 - 12.50 Lbs. BAGS
BLUE/WHITE
~N DAY LOGO
~~TI

HIERONYMUS BOSC

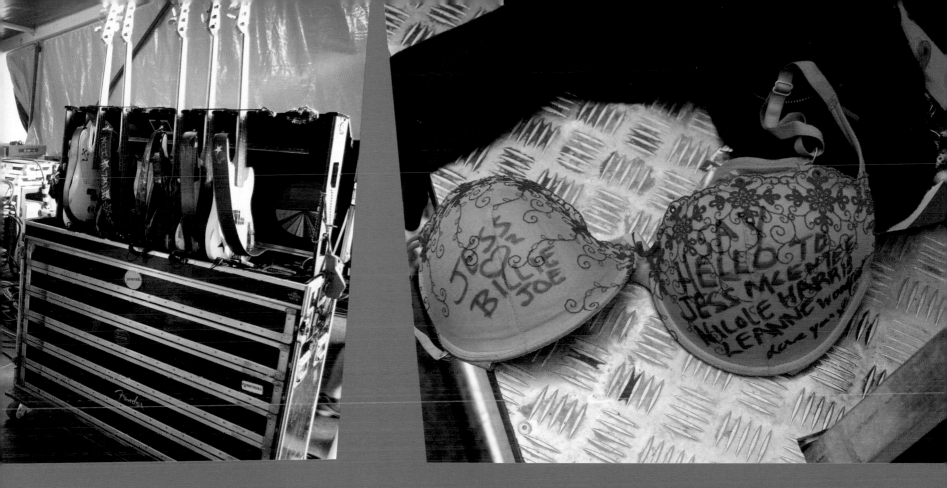

"Tools of the trade."
—*Mike*

An impressive array of instruments and
an overzealous fan's bra, Marlay Park,
Dublin, Ireland, June 23, 2010

"Theater is life.
Movies are art.
Televisions are
background." —*Bob*

THIS SPREAD AND PAGES 126–27
Marlay Park, Dublin, June 23, 2010

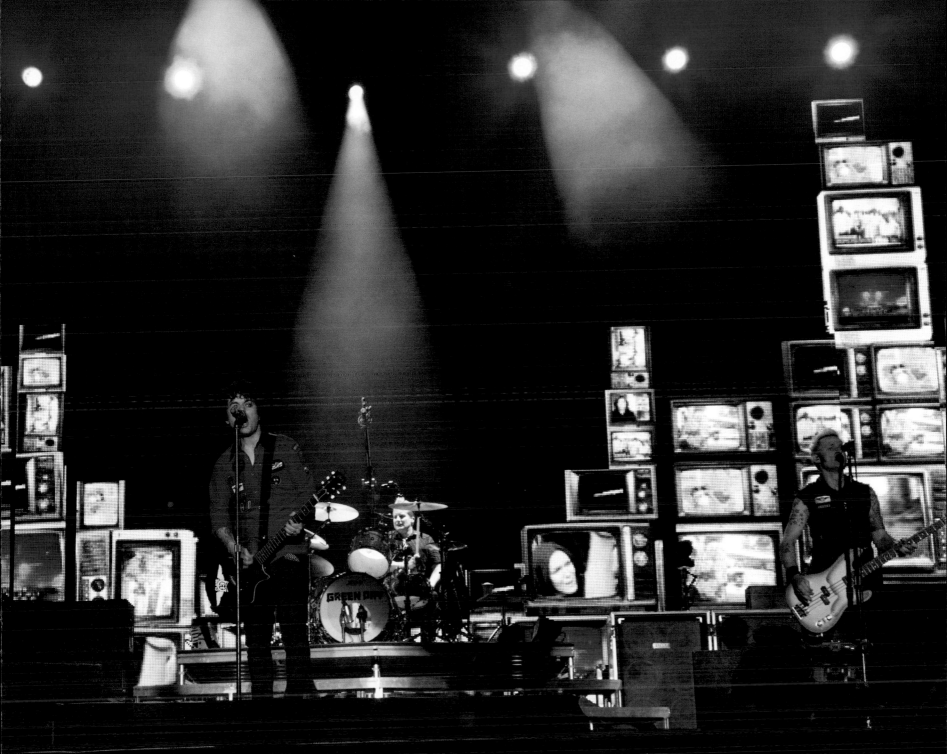

"Our fans love to throw stuff onstage for us to wear. I got a free pair of sunglasses!"
—Billie Joe

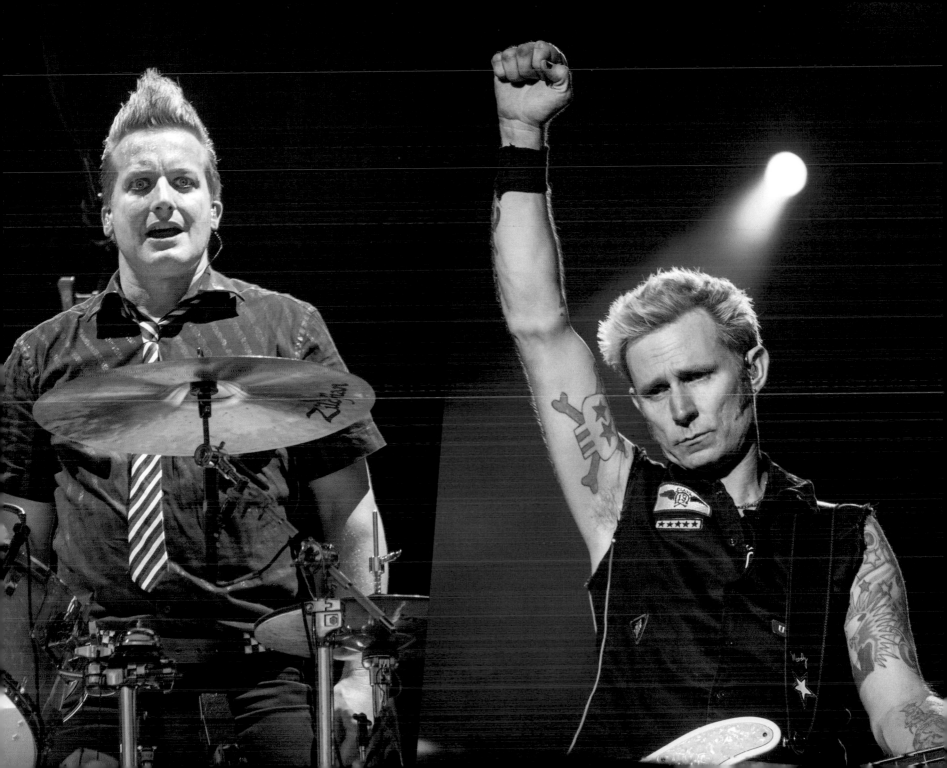

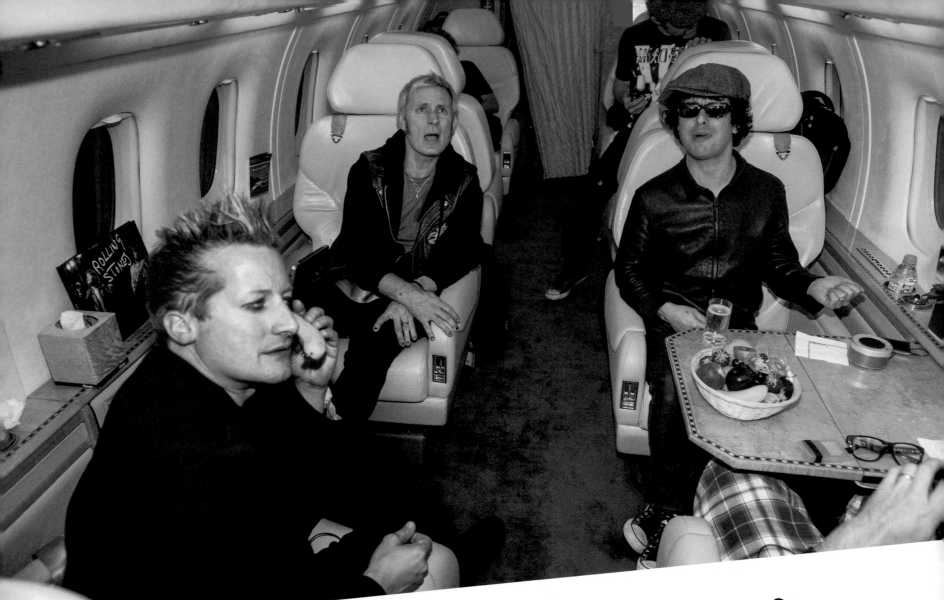

"Never let Tré Cool fly
your plane...Not kidding!"
—Billie Joe

Dublin to Paris, June 24, 2010

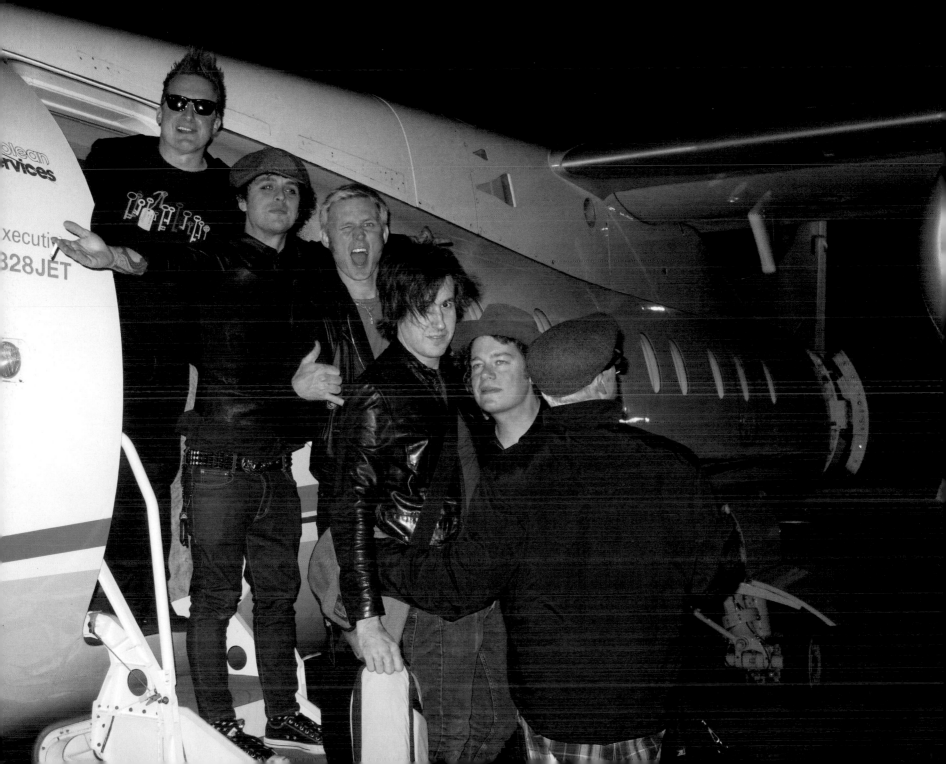

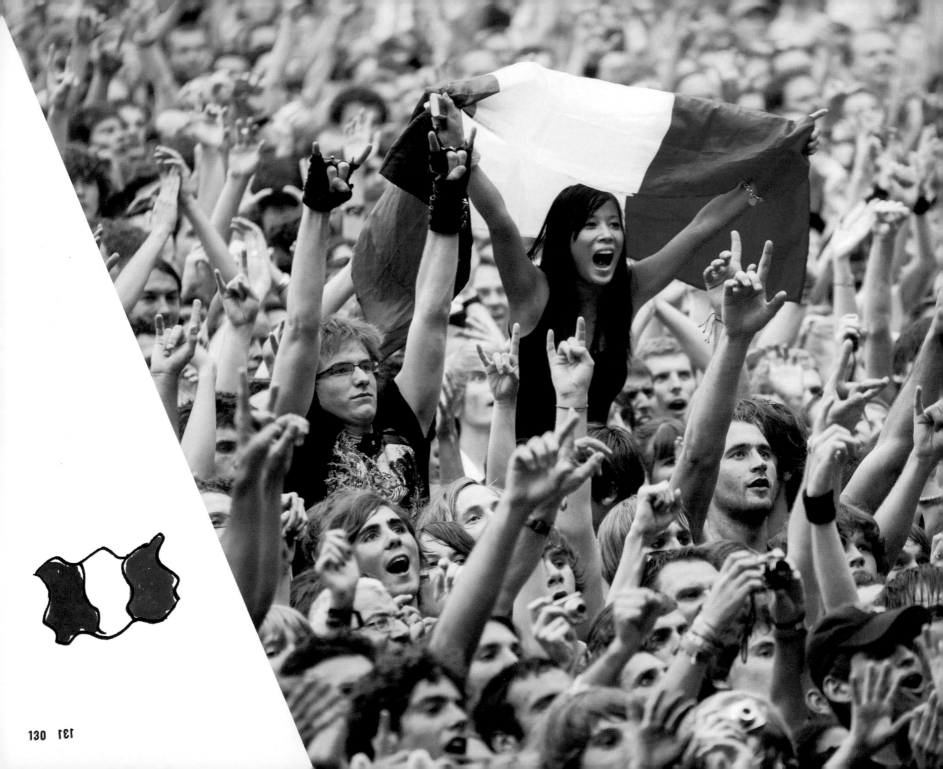

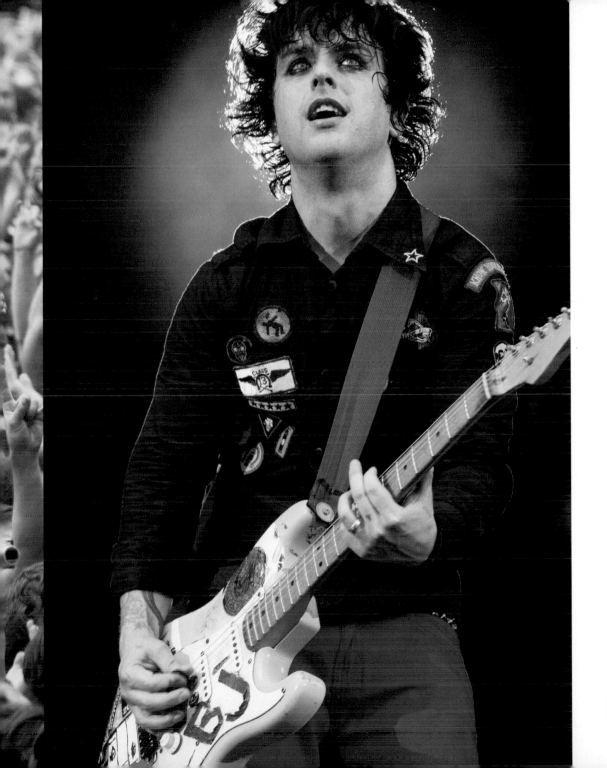

"Green Day heads are the most passionate... I know everyone says it, but this is actually true."
—Billie Joe

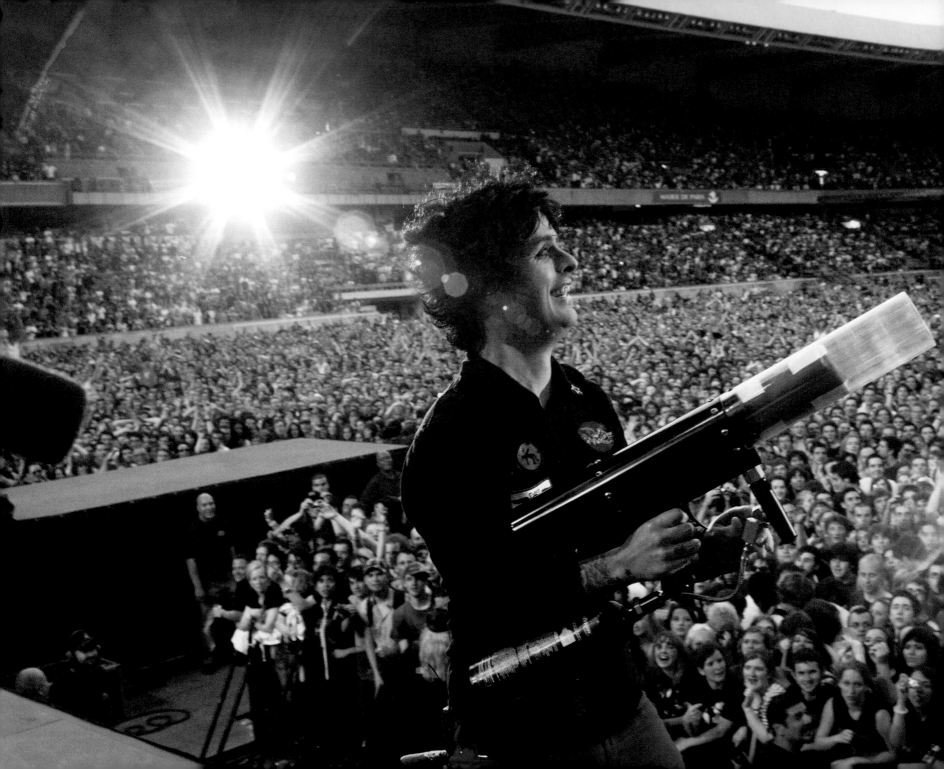

"You're welcome."
—Green Day

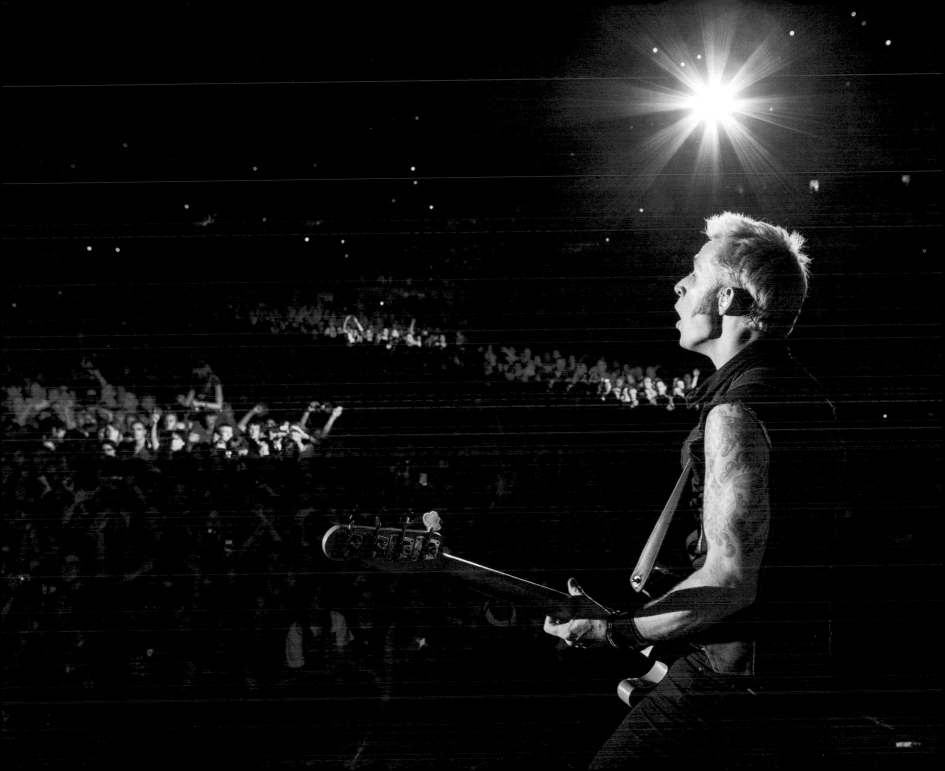

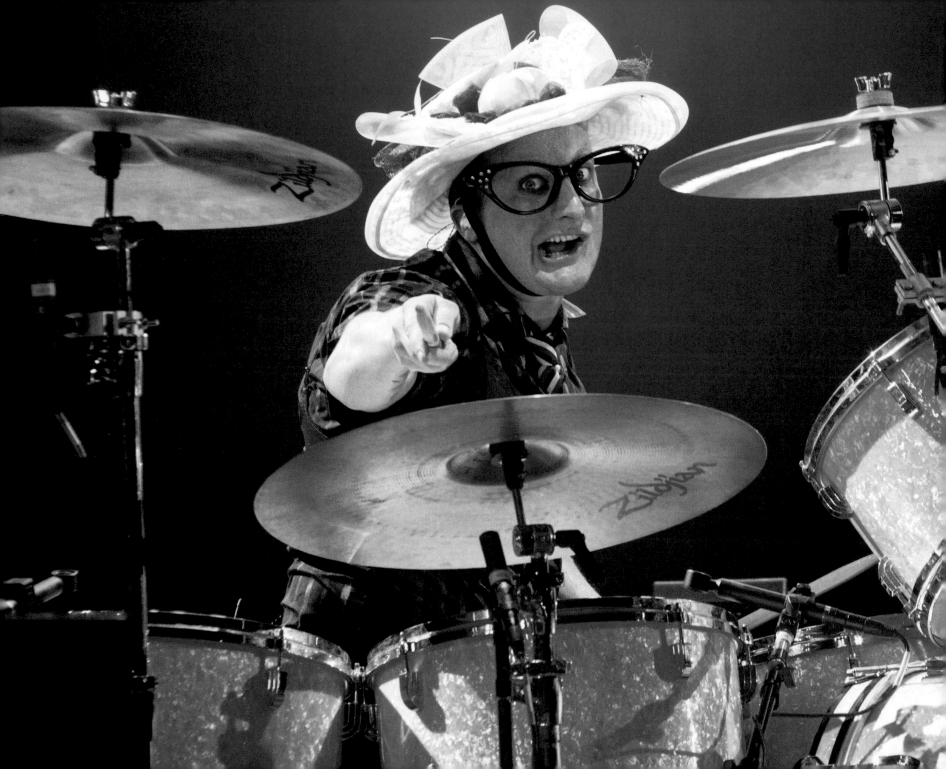

"I spoke to Wavy Gravy, who ran the clown school that Tré attended. He said Tré only wanted to play drums."
—Bob

THIS SPREAD AND PAGES 138–39
Susquehanna Bank Center,
Camden, NJ, August 3, 2010

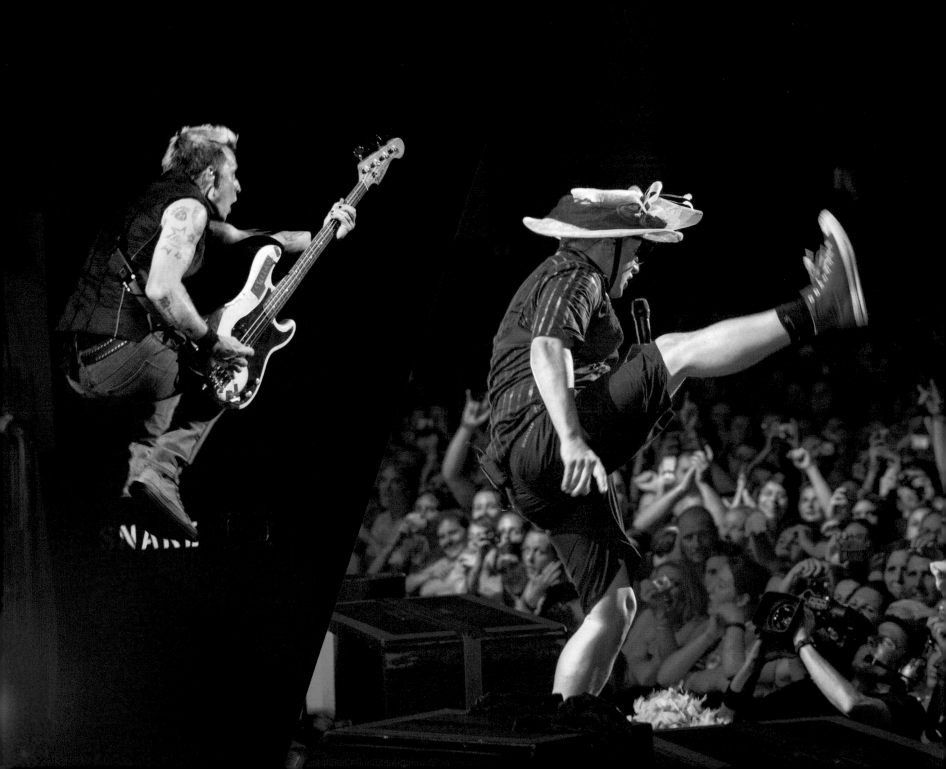

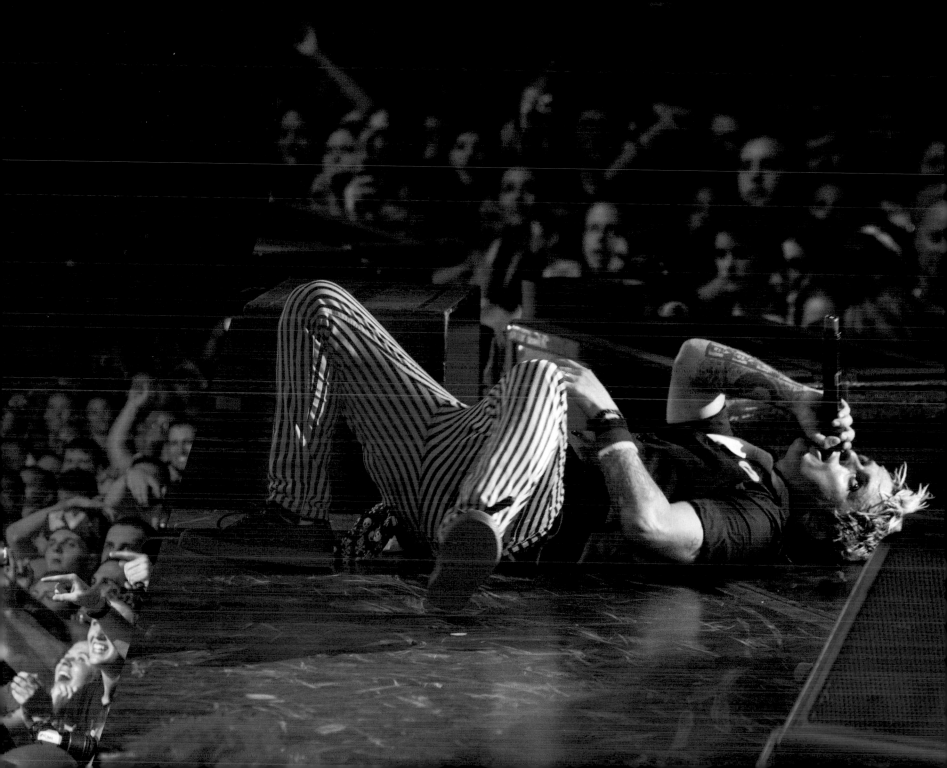

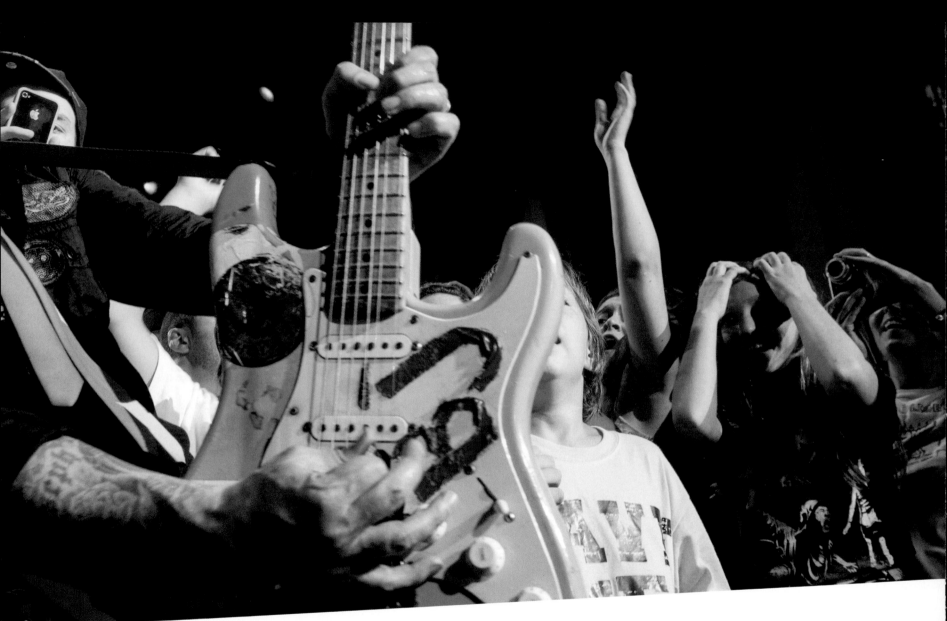

"Thanks for the guitar, mom... I think this rock & roll thing worked out pretty good."
—*Billie Joe*

THIS SPREAD AND PAGES 142–43
PNC Bank Arts Center,
Holmdel, NJ, August 14, 2010

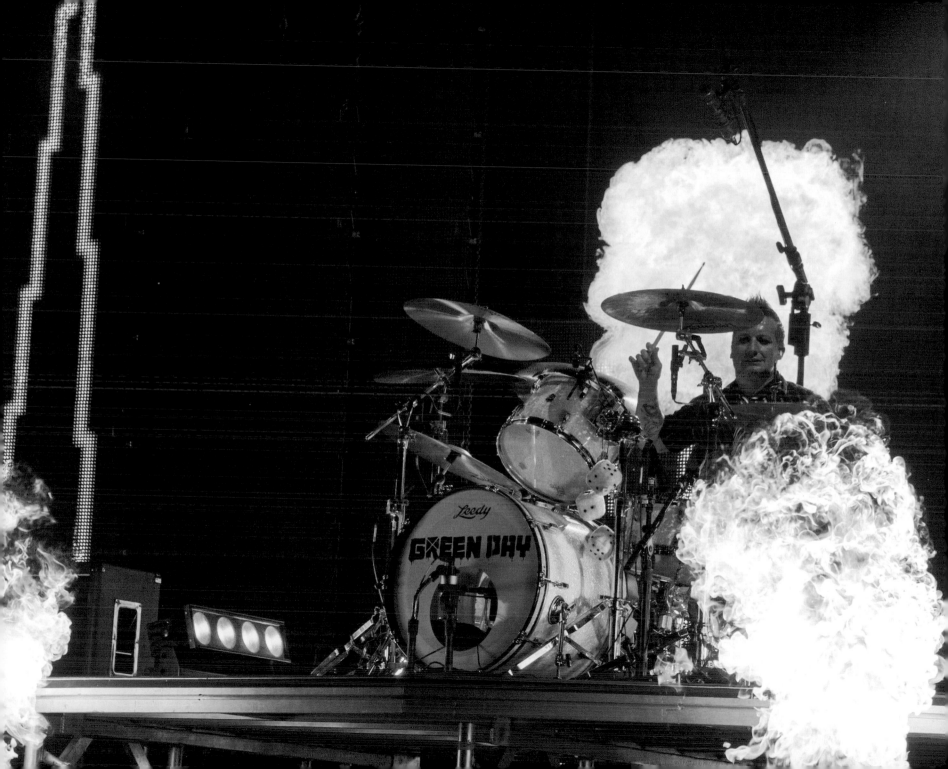

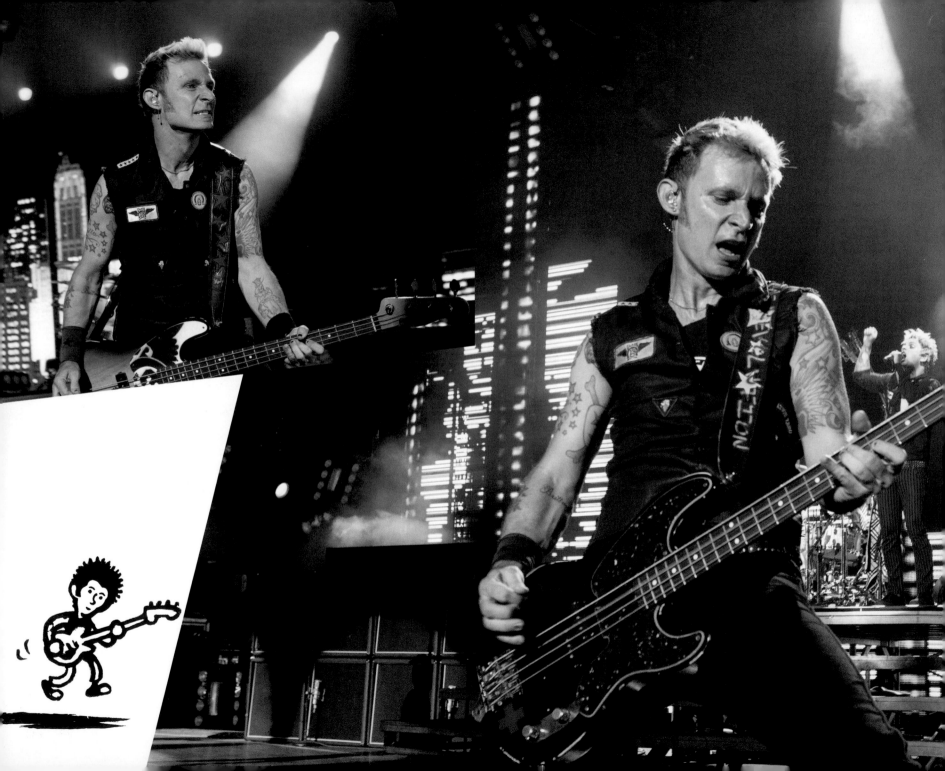

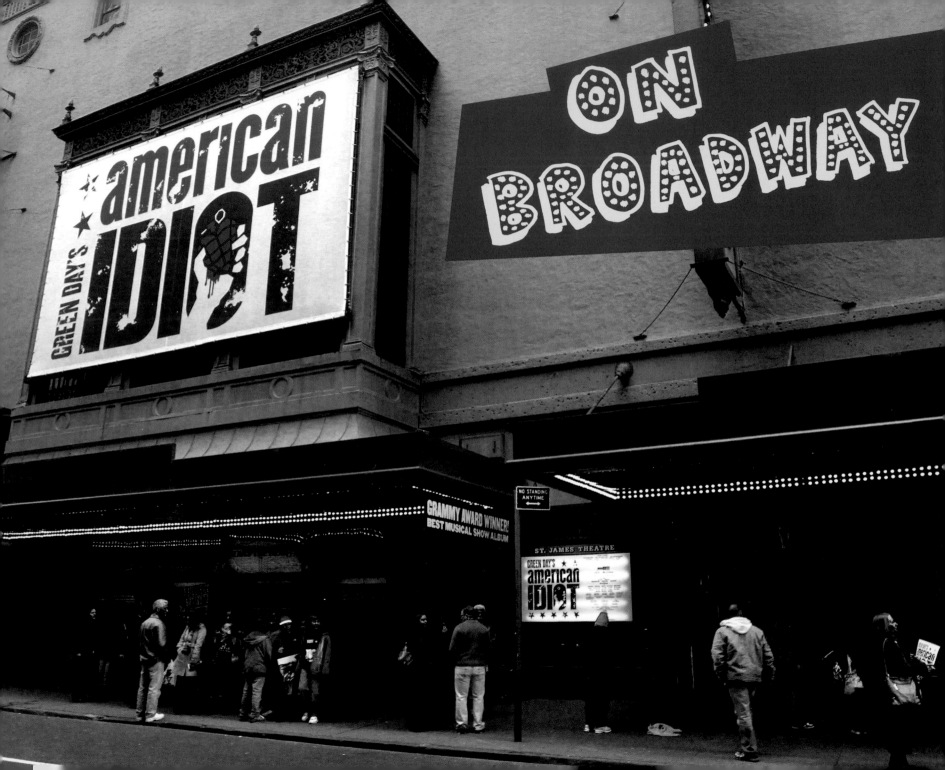

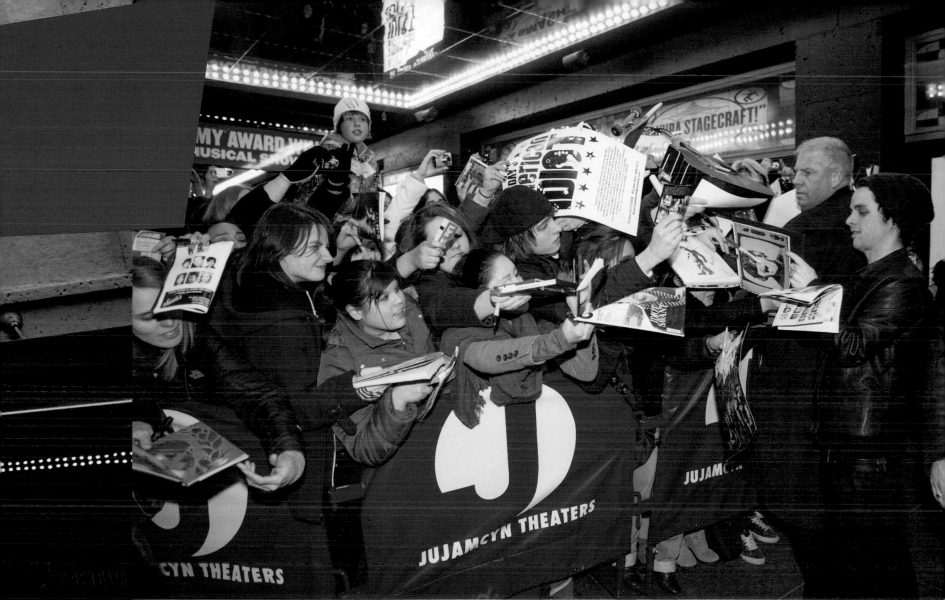

Stopping to sign autographs for fans outside of
American Idiot on Broadway, the St. James Theatre,
NYC, February 24, 2011

Before (ABOVE) and after makeup (OPPOSITE). And showing off a grade school homework assignment come true, the St. James Theatre, NYC, February 24, 2011

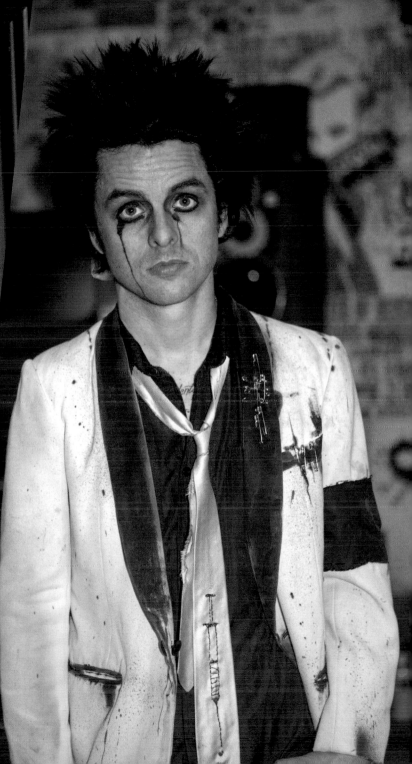

Billie

When I Grow Up

When I grow up..............
I want to have a band that can
play rock and roll. Wer will
start out at the age of fifteen.
Then it will bigger and bigger.
At the age of 20 we will have
geat big ampwillfires and
giuters. At age of 29 well go
ter big time. Well play for
a lot of people. And then well
have a huge band that can be
reel lowed. And then play for
even more things. We will
make alot of people Happy
And wellhave alot of Money.
But if I dont get a band
then I am going to have to
do something els. I could be
a football player? Thats weit
Ill be. we will travll all ofer
the plays we will win all
of are games. And we will
be the champs. But what if
I don't play football. I dont
wait I be. I now. Ill be something.
 The end. I'd bet on that!

Sounds
great!

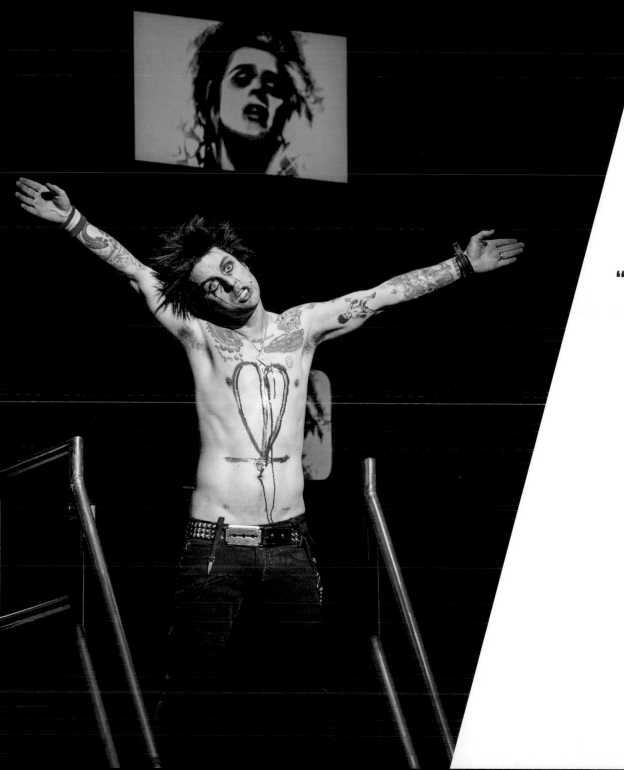

"Billie Joe was just
as good at acting on
Broadway as he is at
being a rock star."
—*Bob*

"American Idiot opened April 20, 2010, on Broadway, and closed April 24, 2011, after 421 performances and 27 previews. This was closing night, and Green Day came out after to play an hour-long surprise concert, with the cast joining in onstage!" —Bob

Green Day performing on the closing night of *American Idiot*, the St. James Theatre, NYC, April 24, 2011

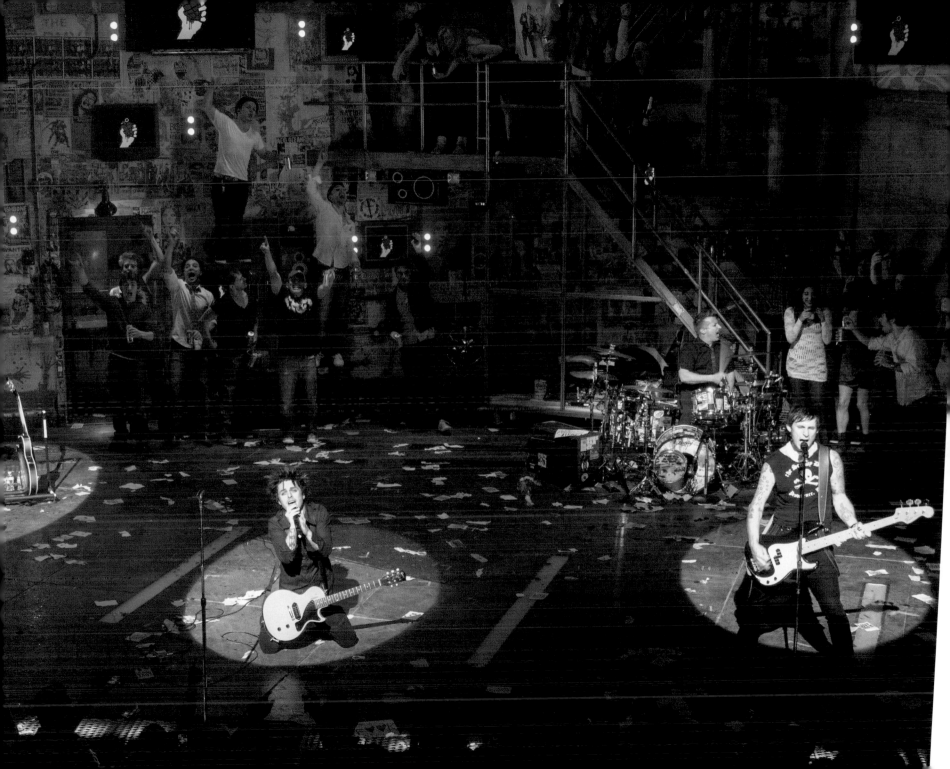

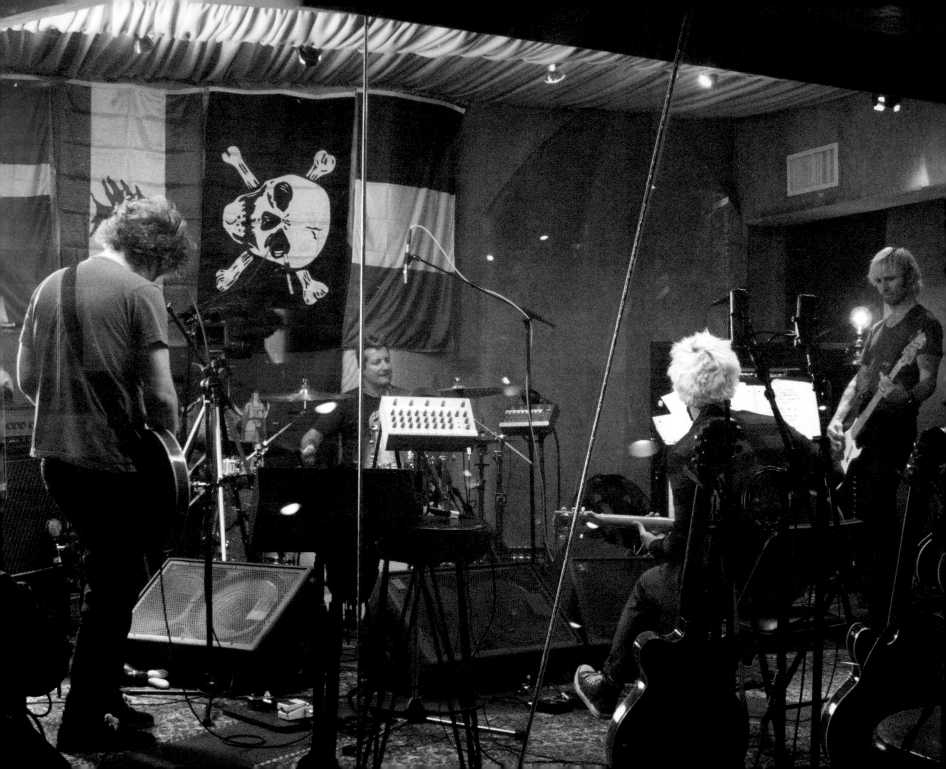

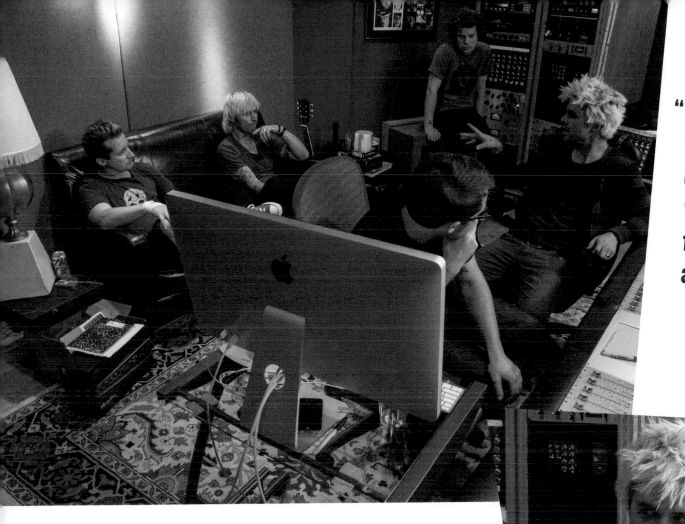

"These pictures were taken during one of our New York City writing sessions for *¡Uno!*, *¡Dos!*, and *¡Tré!*"

—Billie Joe

Electric Lady Studios, NYC,
October 20, 2011

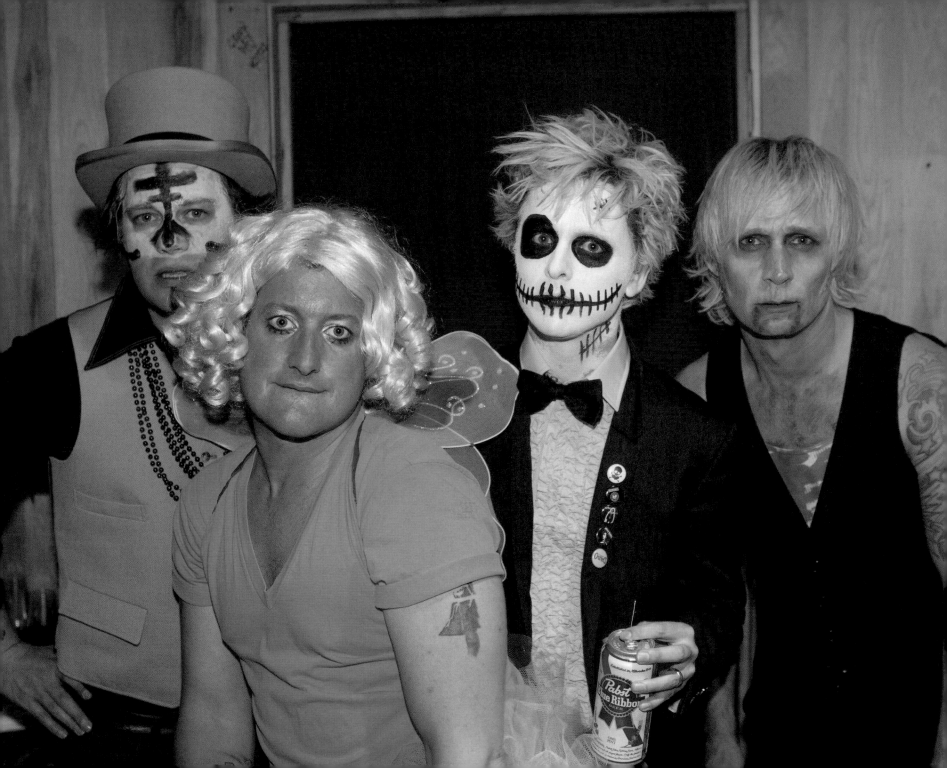

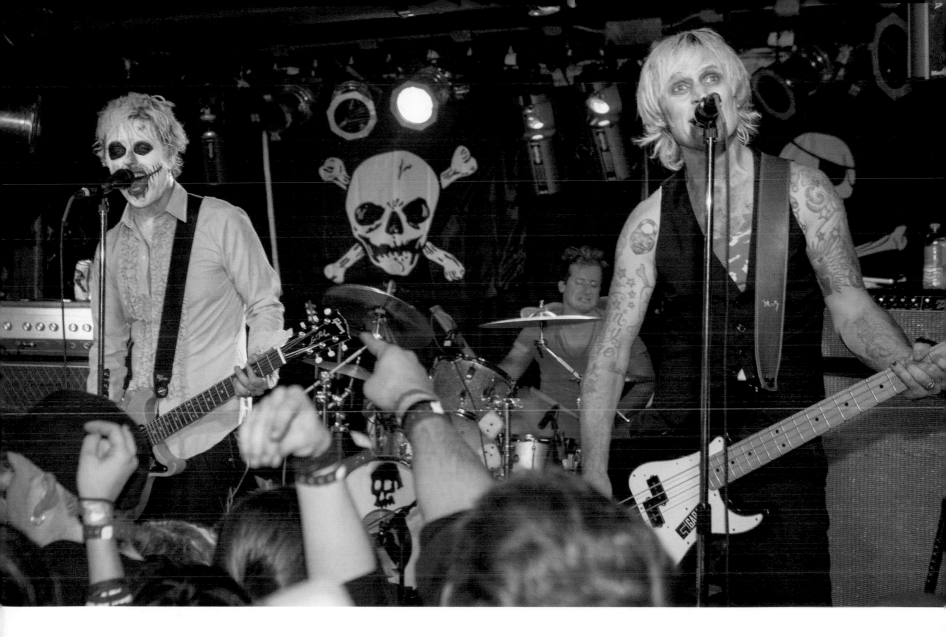

Halloween at the Studio at Webster Hall,
NYC, October 27, 2011

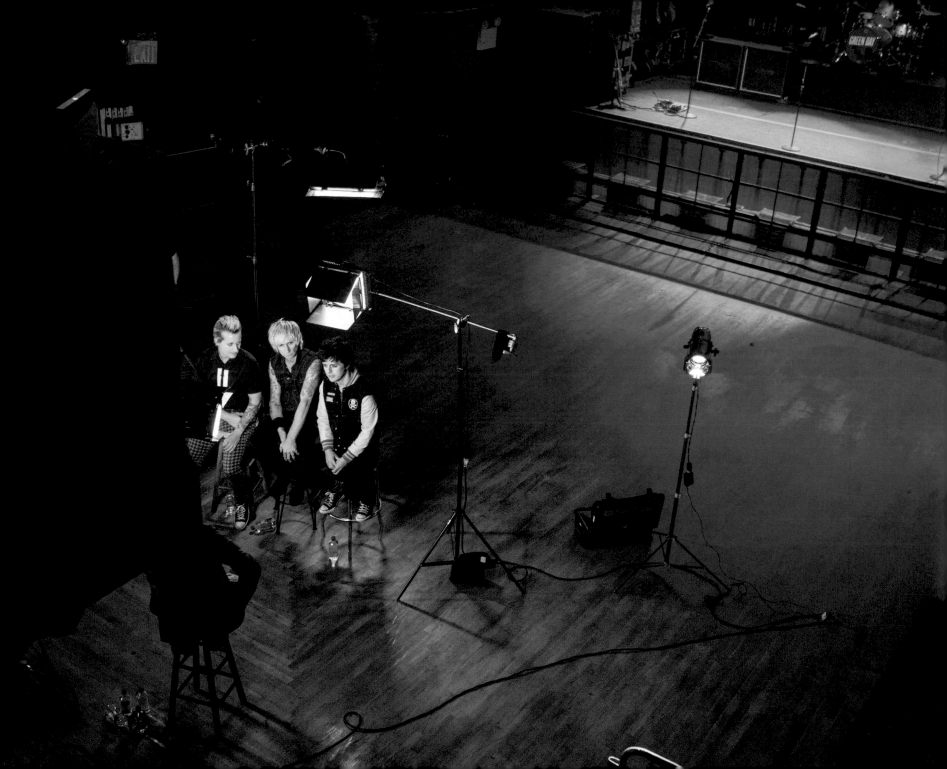

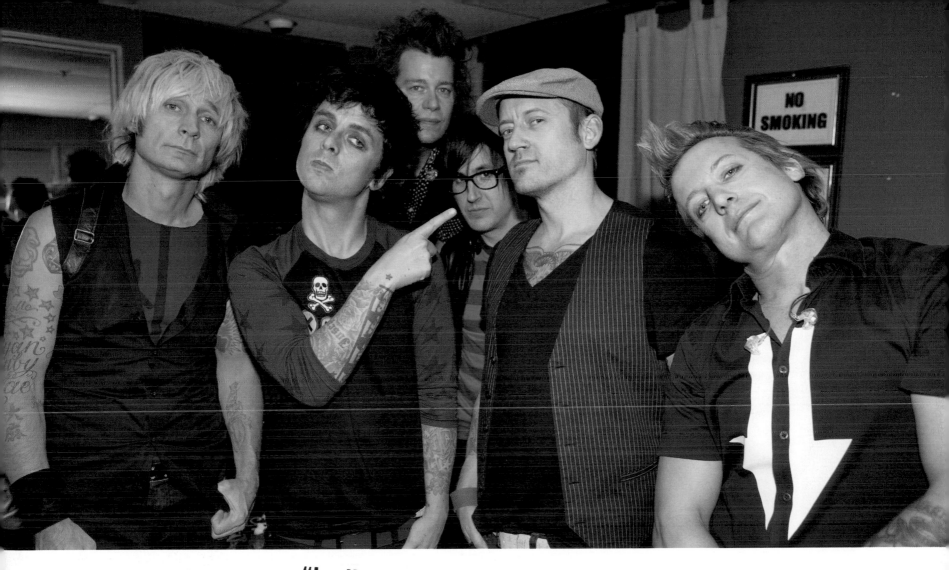

"Ladies and gentlemen, the big three—Jason White, Jeff Matika, and Jason Freese. We are so lucky to have these guys!" —Billie Joe

Being interviewed (OPPOSITE) and backstage before a performance (ABOVE) to celebrate the release of their album ¡Uno!, Irving Plaza, NYC, September 15, 2012

PAGES 158–59
Irving Plaza, NYC,
September 15, 2012

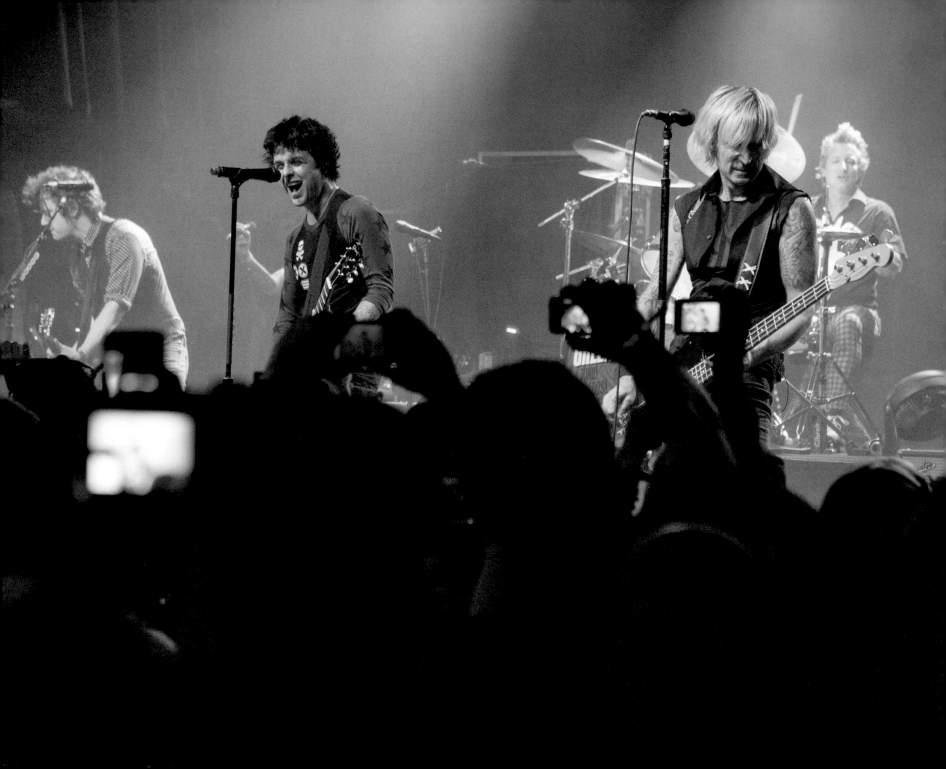

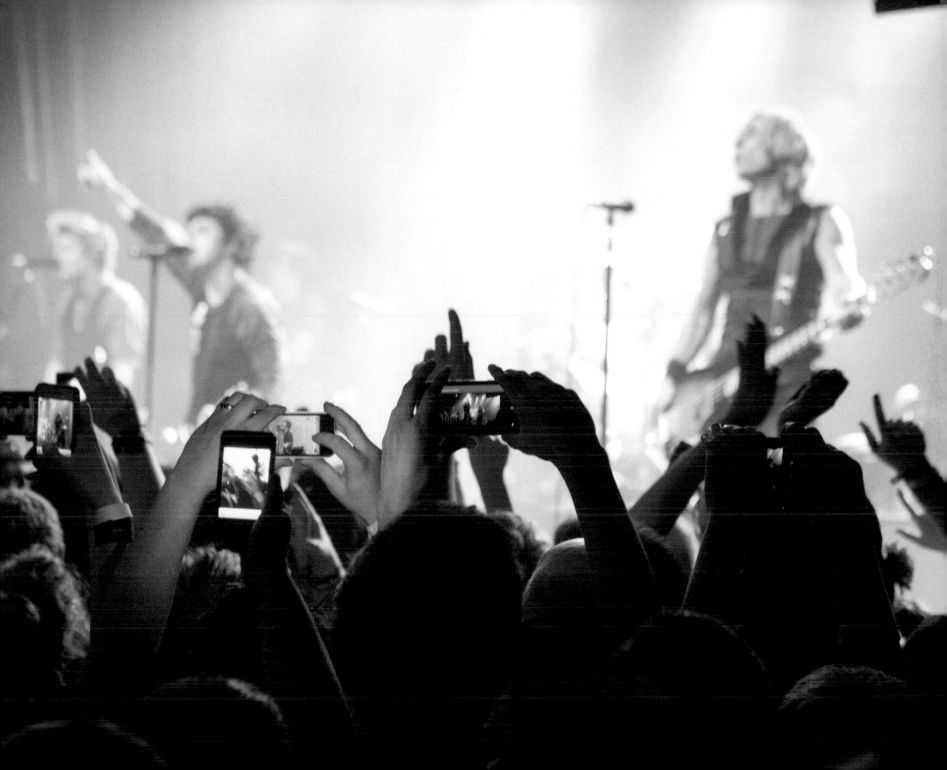

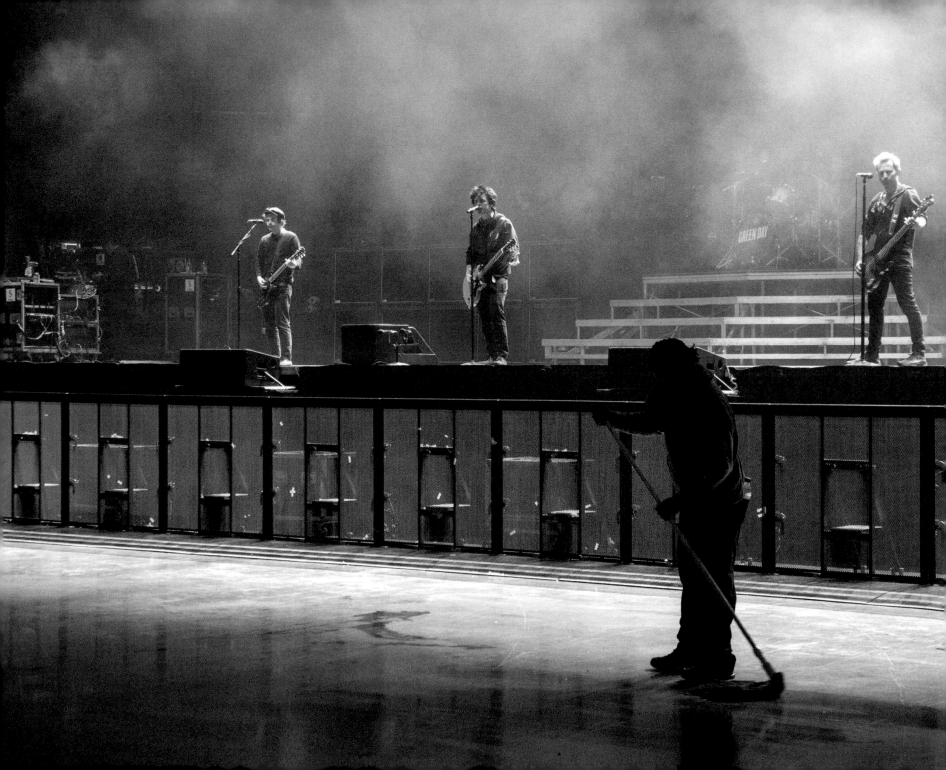

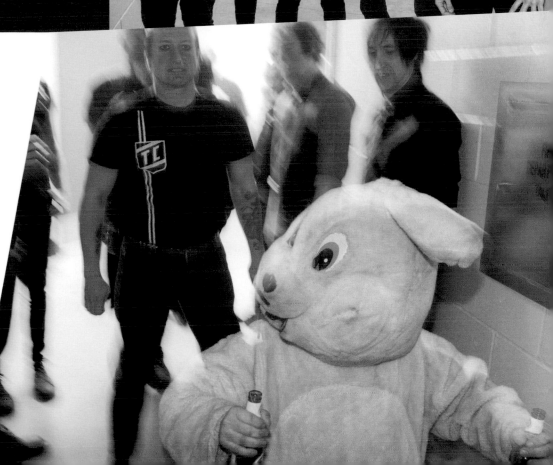

THIS SPREAD AND PAGES 162–63
99 Revolutions tour, Barclays Center,
Brooklyn, New York, April 7, 2013

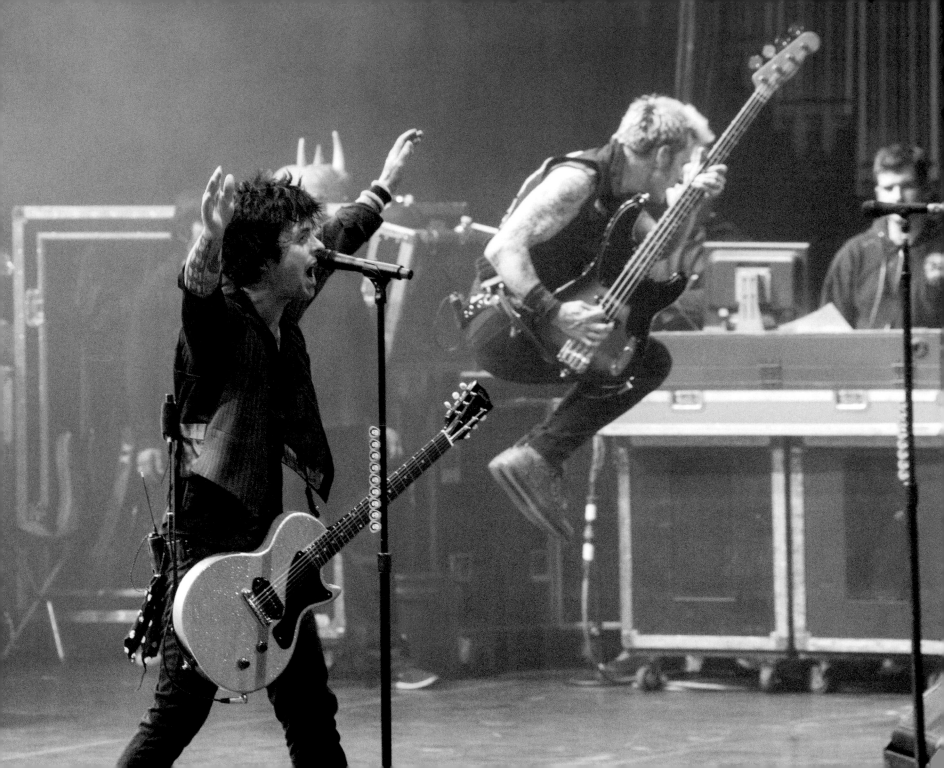

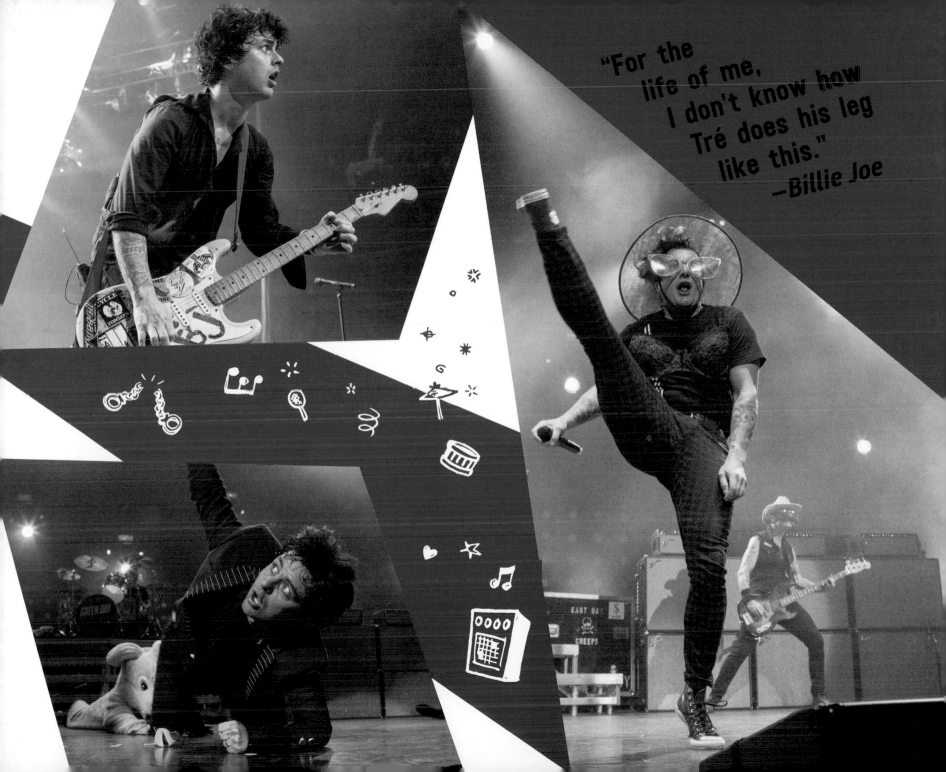

"For the life of me, I don't know how Tré does his leg like this."
—Billie Joe

During their induction into the Rock & Roll Hall of Fame. (LEFT TO RIGHT) Leon Bridges, Miley Cyrus, Mike Dirnt, Billie Joe Armstrong, Joan Jett, Paul McCartney, Ringo Starr, and Joe Walsh for a rendition of the Beatles' "With a Little Help from My Friends," Public Hall, Cleveland, Ohio, April 18, 2015

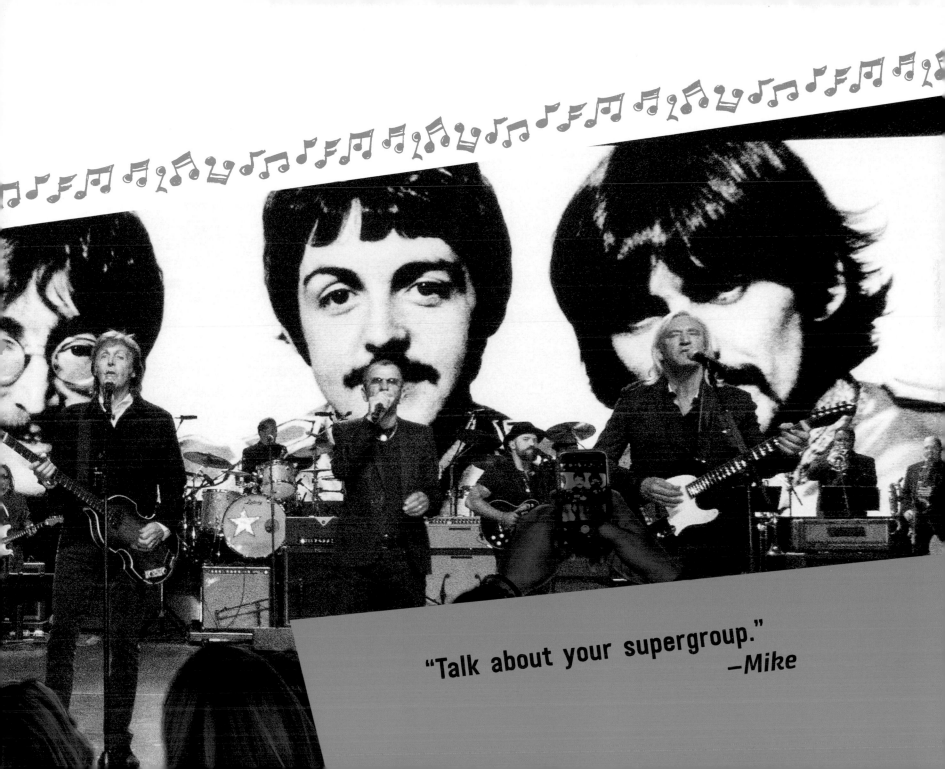

"Talk about your supergroup."
—Mike

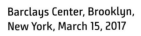

Barclays Center, Brooklyn,
New York, March 15, 2017

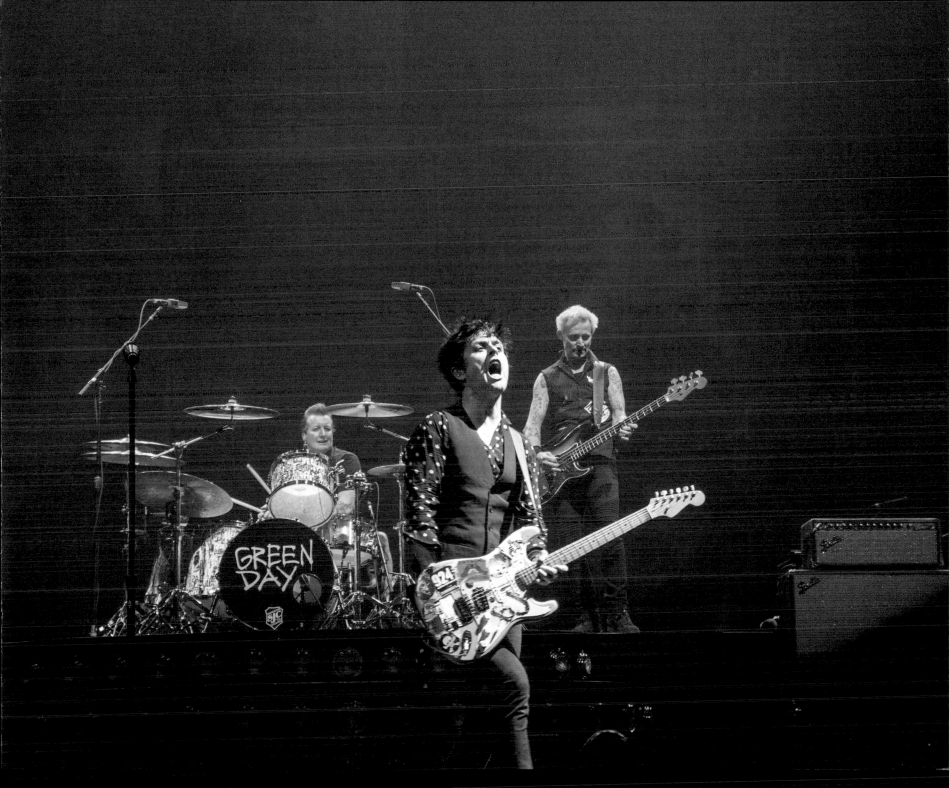

"So many balls, so little time." —*Tré*

British Summer Time Festival, Hyde Park, London, England, July 1, 2017

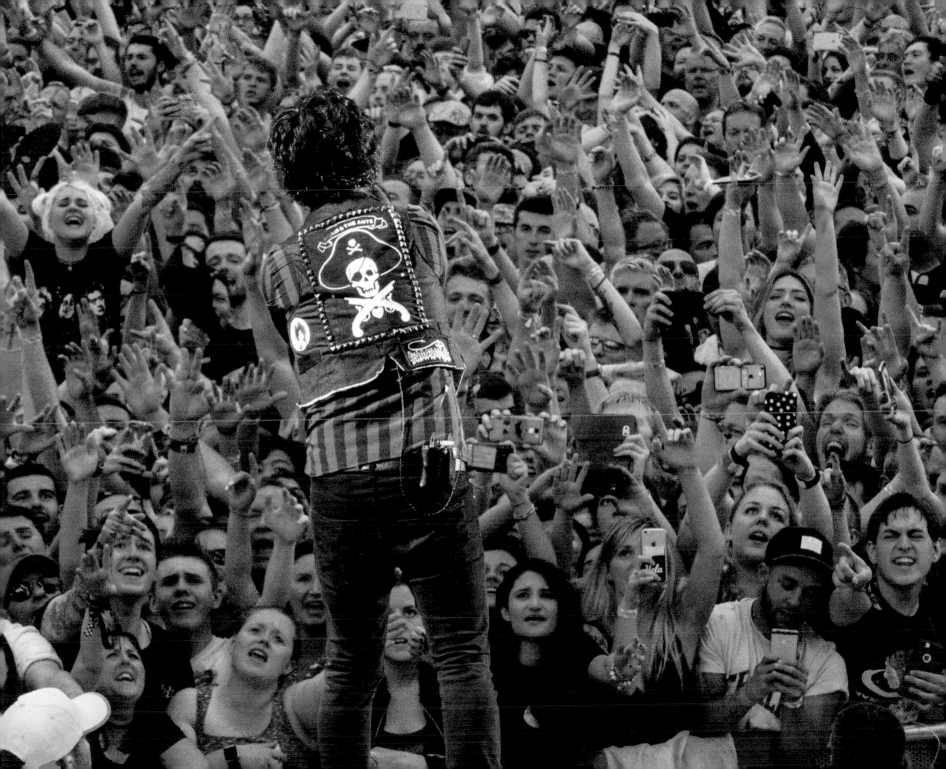

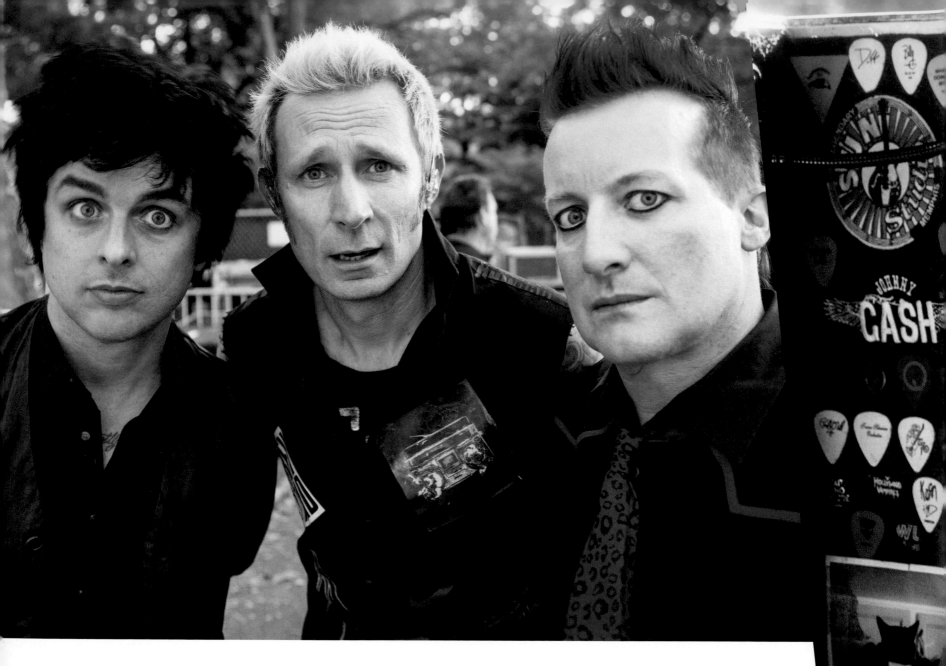

THIS SPREAD AND PAGES 172–75
Global Citizen Festival,
Central Park, NYC,
September 23, 2017

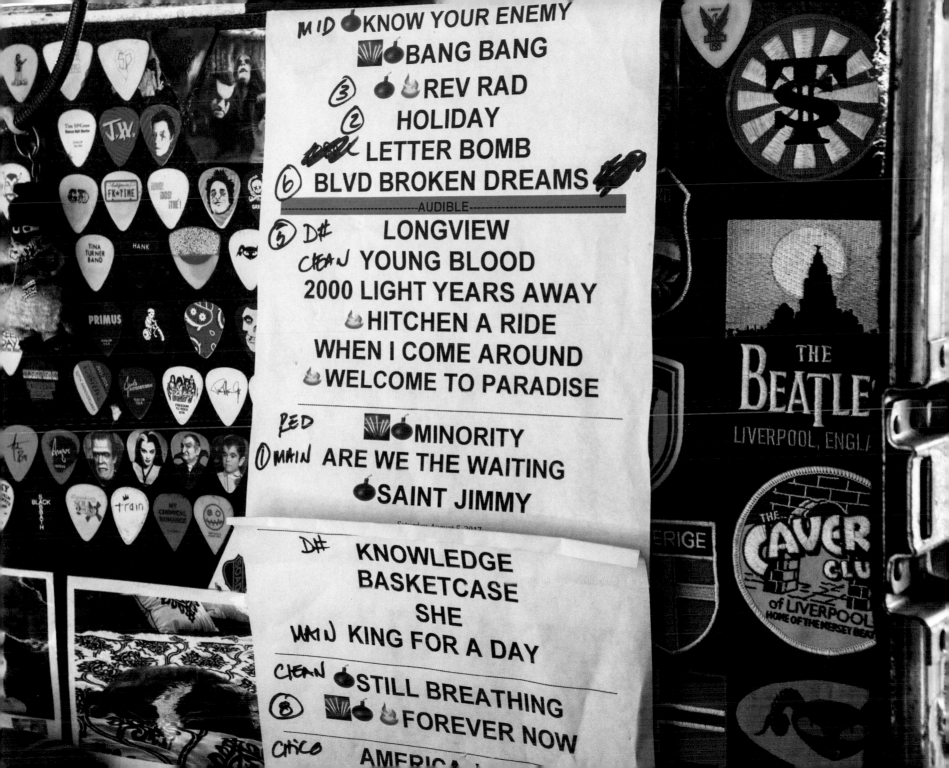

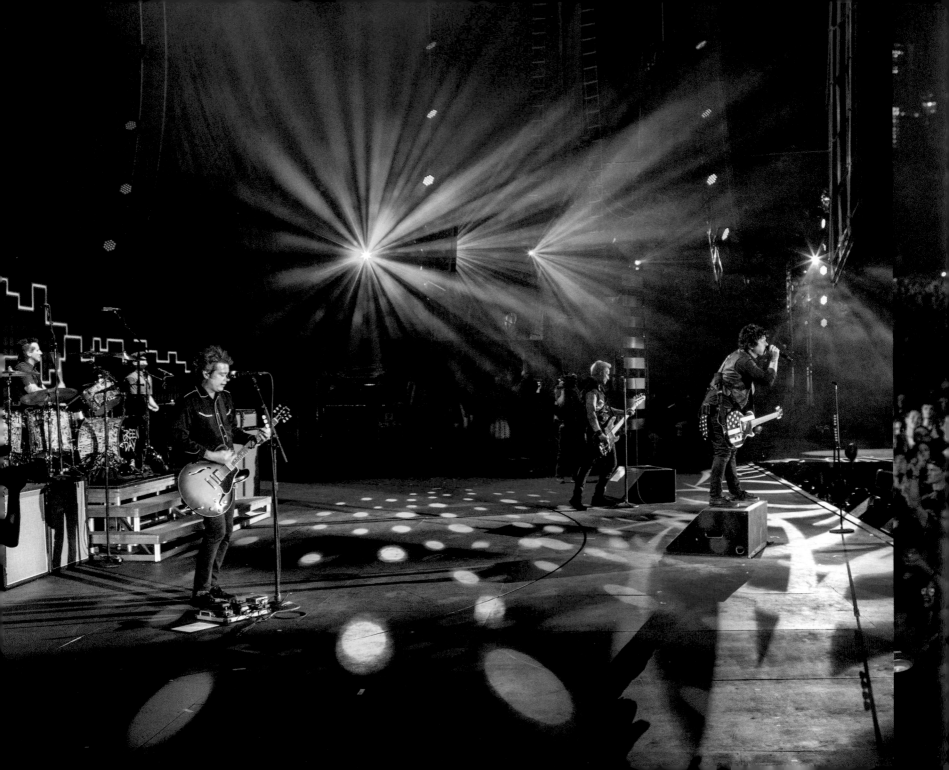

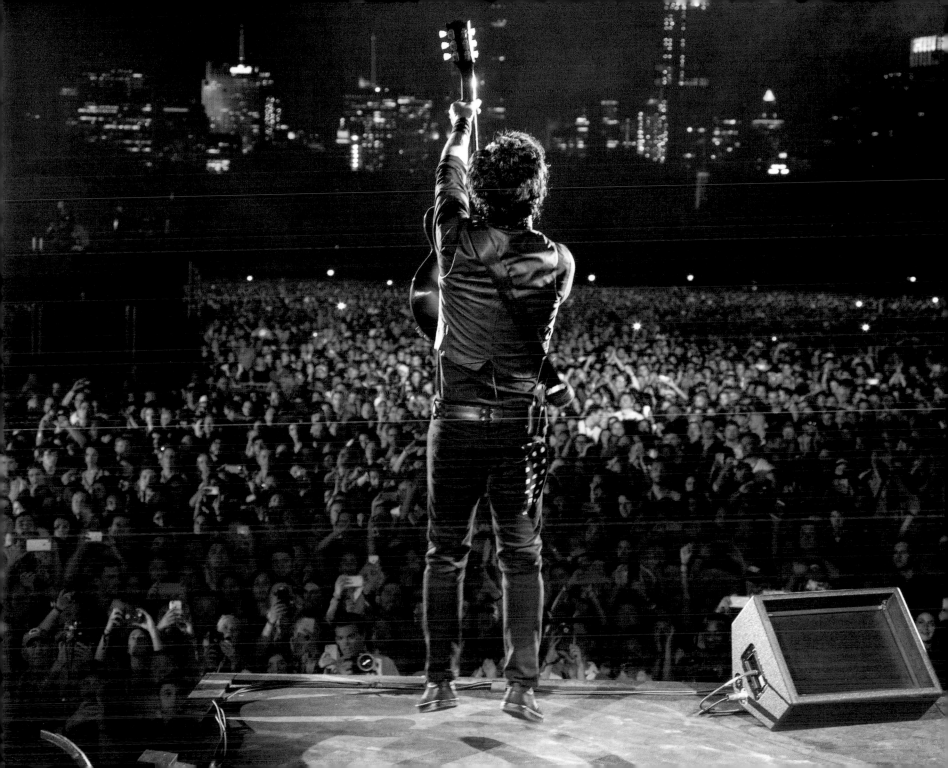

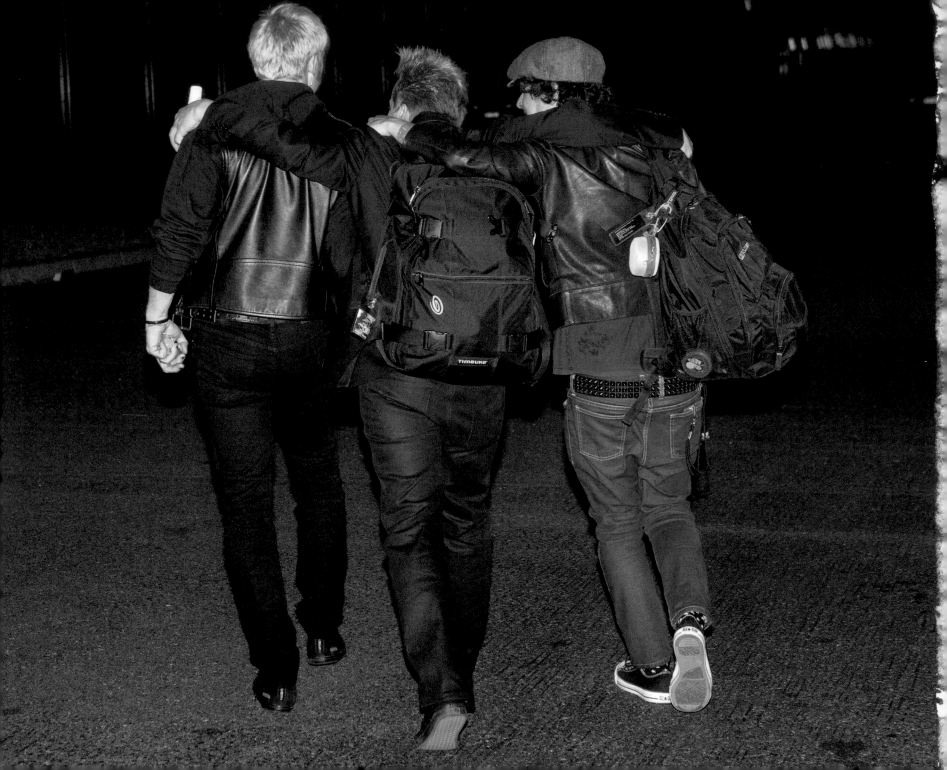